W9-BVB-197

WELLES-TURNER MEMORIAL LIBRARY
GLASTONBURY, CT. 06033

DISCARDED BY
WELLES-TURNER
MEMORIAL LIBRARY
GLASTONBURY, CT

MILLER-TURNER MEMORIAL LIBRARY
GLASTONBURY, CT 06033

DISCARDED BY
WELLES-TURNER
MEMORIAL LIBRARY
GLASTONBURY, CT

Michael Jacobs

MYTHOLOGICAL PAINTING

MAYFLOWER BOOKS
NEW YORK

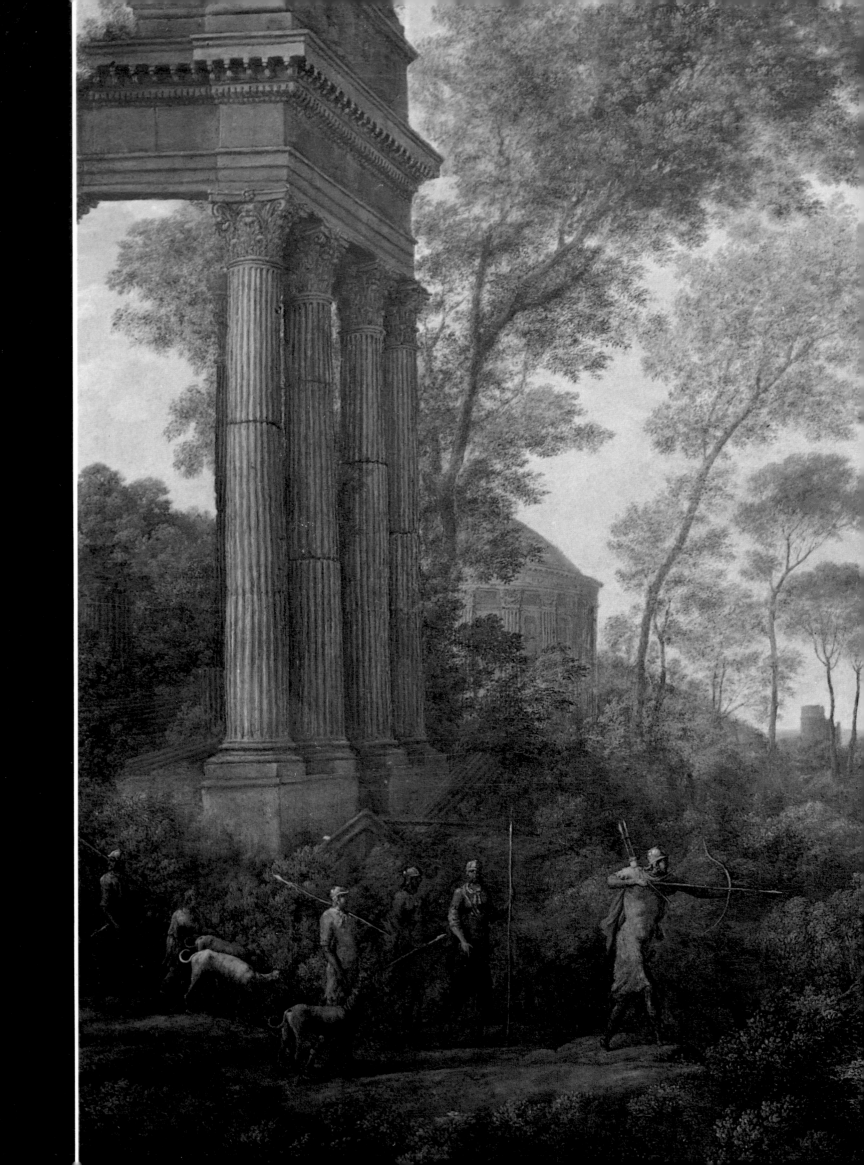

Michael Jacobs

MYTHOLOGICAL PAINTING

WELLES-TURNER MEMORIAL LIBRARY
GLASTONBURY, CT 06033

+753.7
J17m

OVERLEAF **Claude**: *Ascanius Shooting the Stag of Sylvia* (detail), 1682

MAYFLOWER BOOKS, INC.,
575 Lexington Avenue, New York City 10022.

© TEXT 1979 Phaidon Press Limited
© DESIGN 1979 Heraclio Fournier, S. A.

The film positives of the illustrations are
the property of Heraclio Fournier, S. A.

All rights reserved under International and Pan
American Copyright Convention.
Published in the United States by Mayflower Books,
Inc., New York City 10022.
Originally published in England by Phaidon Press,
Oxford.

No part of this publication may be reproduced, stored
in a retrieval system, or transmitted, in any form or by
any means, without prior written permission of the
publishers. Inquiries should be addressed to Mayflower
Books, Inc.

Library of Congress Cataloging in Publication Data

 JACOBS, MICHAEL.
 Mythological painting.

 1. Mythology, Classical, in Art. 2. Painting —
Themes, Motives. I. Title. II. Series.
ND1420.J3 753'.7 78-25563
ISBN 0-8317-6282-9
ISBN 0-8317-6283-7 pbk.

Printed and bound in Spain by HERACLIO FOURNIER SA. *Vitoria.*
First American edition
Filmset in England by Southern Postives and Negatives
*(*SPAN*), Lingfield, Surrey*

Botticelli: *Primavera*, 203 × 314cm, c.1477

The *Primavera* and the slightly later *Birth of Venus*, the first paintings since antiquity to depict almost life-sized classical deities, have been the source of endless and generally unproductive speculation. As the title of the first would imply, some allegory of the spring is meant. In Ovid's *Fasti*, a poetic calendar describing the activities of each month, a story is told about the origins of Flora, whose feast was celebrated in Spring; a nymph of the fields, Chloris, was apparently transformed into Flora on being touched by Zephyr, the West Wind. This scene is depicted on the righthand side of Botticelli's painting, and on the left are the three Graces who, again in accordance with Ovid's description, are shown celebrating the event. What the two remaining figures, Mercury and Venus, are doing is not clear, however, and it is unlikely that any specific classical text describing all the elements in the painting will ever be found; Renaissance allegories were frequently piecemeal compilations of a variety of ideas. What might turn out as the biggest red herring of all is the work's putative association with Neo-Platonism. The *Primavera* and *The Birth of Venus* were seen by Vasari in the Medici villa of Castello, which in Botticelli's time was owned by Lorenzo di Pierfrancesco de' Medici, a cousin once removed of Lorenzo the Magnificent, and a friend and pupil of Marsilio Ficino, the founder of the Neo-Platonic movement in Florence. Another tenuous link in the chain is provided in a letter from Ficino to Pierfrancesco, written about the same time as the *Primavera* was painted, in which the virtues of *humanitas* were emphasized as the most priaseworthy in a young man; Ficino personified the concept in the figure of Venus, who indeed appears in the centre of Botticelli's painting.

Mythological Painting

THE INTELLECTUAL AND SOCIAL CONDITIONS that made classical mythology such a vital force in European art for nearly three hundred years had drastically changed by the end of the eighteenth century. Today this world of deities, enacting myths with which one is no longer familiar, taking part in allegories that uphold obscure principles or glorify forgotten personalities, seems even more alien to contemporary sensibility. The erroneous deduction from all this is that mythological paintings can now only be appreciated by those with the seriousness of purpose and single-minded determination of an academic. This is a sad sequel to what was one of the livelier traditions in Western painting, and one that was openly concerned with pleasure, whether intellectual or, as was more usual, profane. The revival of interest in antiquity in the Renaissance brought about a type of painting that must have seemed a very attractive alternative

to religious art, and many of the mythological paintings of the time were commissioned out of questionable motives. Typical of the new sort of patron was Duke Federigo Gonzaga, who, on ordering in 1524 a work from Sebastiano del Piombo, insisted on 'none of your saints' stuff, but something pleasant and beautiful to look at'. Federigo's taste was, in fact, clearly for the erotic; so often beneath the quaint artifice of mythology, one finds more instinctive human concerns.

Undoubtedly, the most incomprehensible aspect of the history of mythological painting is the body of critical literature that has grown up around it. To judge pictures of mythological subjects for their purely visual qualities is clearly unsatisfactory; however to go to the other extreme and view the works as examples of the most involved iconography is frequently a reaction as insensitive as the art theories that

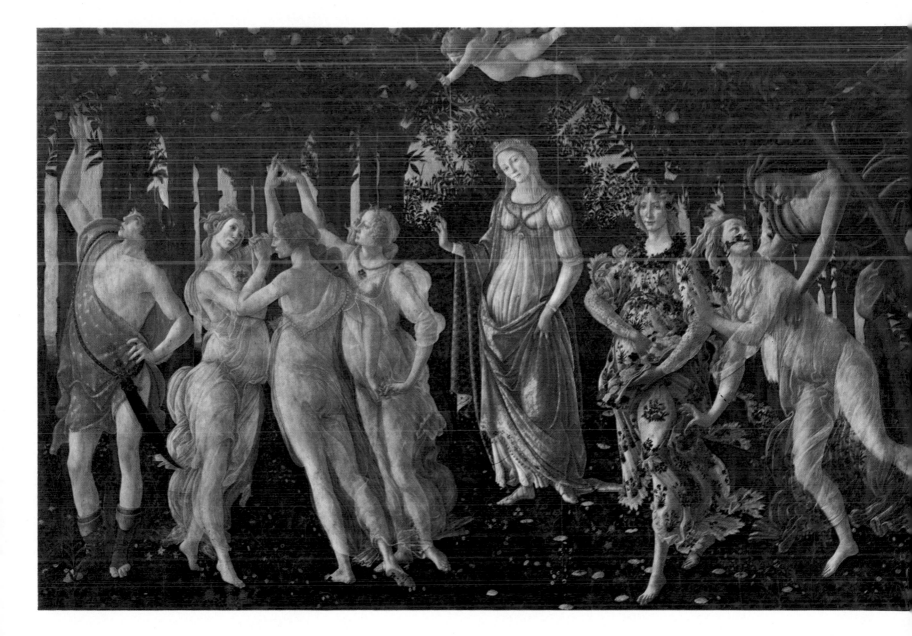

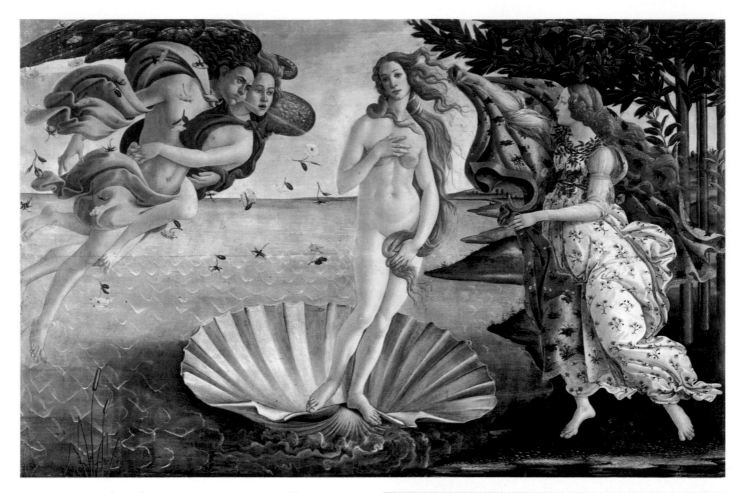

Botticelli: *The Birth of Venus*, 175 × 278cm, and detail, c.1480–5

Ficino's personification of *humanitas* in the figure of Venus would, on the face of it, seem doubly applicable to this painting, yet there is no evident reason why this work should be an allegory at all. Another of Pierfrancesco's friends was the poet, Politan, whose *La Giostra*, celebrating the famous joust of Giuliano de' Medici in 1475, included a description of Venus's palace and its decorations; one of these was a relief which depicted the birth of the Goddess from the sea. If any allegory was intended in Botticelli's painting it must have been an afterthought, for surely the artist initially responded to the exciting challenge of recreating this relief himself. The rather sad expression in Venus's face is probably the main reason why the painting is generally considered a work of such profundity. Its mood is certainly ambiguous, and has been interpreted both in terms of refreshing vitality (thus ideally suited for advertising cosmetics) and, in the case of Walter Pater, morbid introspection. These very divergent reactions are due to the tentative quality of a painting which, like the *Primavera*, represented a new category of art, and, in its very linear quality and tapestry-like composition, was soon to seem old-fashioned. Rather than being seen to mirror the highest achievements of the human mind, it is this naive, unformed aspect of the painting which should be emphasized.

were current when the paintings were made. The basis for these theories was a misapplied interpretation of certain classical authors. In the treatises on poetry by Aristotle and Horace, as well as in other classical writings, comparisons had been made between poetry and painting. These similes (the most famous of them being Horace's *ut pictura poesis* — 'as is painting so is poetry') were only intended to illuminate the art of poetry, but by later writers they were taken out of context and interpreted as a valid doctrine for painting itself. Central to this reinterpretation of the two arts was the need to place the manual activity of the one on a par with the more intellectual pursuits of the other. These were the foundations of the so-called humanistic theory of painting, a theory that formulated strict rules for often irrational areas of creativity, and which naturally established a hierarchy of genres, placing pure landscape and flower painting at the bottom, and paintings with a classical subject at the top. As the history of mythological painting is intimately tied up with the acceptability of humanistic doctrines, some knowledge of this intellectual culture is clearly essential, although not of the intricacies of reasoning which supported it, for so frequently the ideas and theories of writers bore so little relation to actual practice.

The most obvious result of applying humanistic doctrines to painting was the mania for either mythological figures expounding allegorical principles, or classical myths being interpreted in an allegorical way. To a humanistic theorist like Lomazzo, this category of painting was the clearest expression of the axiom of *ut pictura poesis*, and consequently represented the highest form of art. Many of the resulting works are now difficult to decipher, but in several cases the thinkers responsible for devising them actually intended a certain degree of indecipherability. With Poussin and his circle, one of the reasons for this might have been a desire to hide their heretical and unorthodox philosophical views, but generally these thinkers simply wanted to emphasize their superiority over ordinary mortals. Plato's belief in philosophy as a mystical initiation led, for instance, to the childish doctrine, expounded by Neo-Platonists like Pico della Mirandola, that the inaccessibility of sublime revelations heightened their authority. The ironic feature of Botticelli's *Primavera* [Spring] and *Birth of Venus*, works to which Neo-Platonic philosophy is most frequently related, is that they are per-

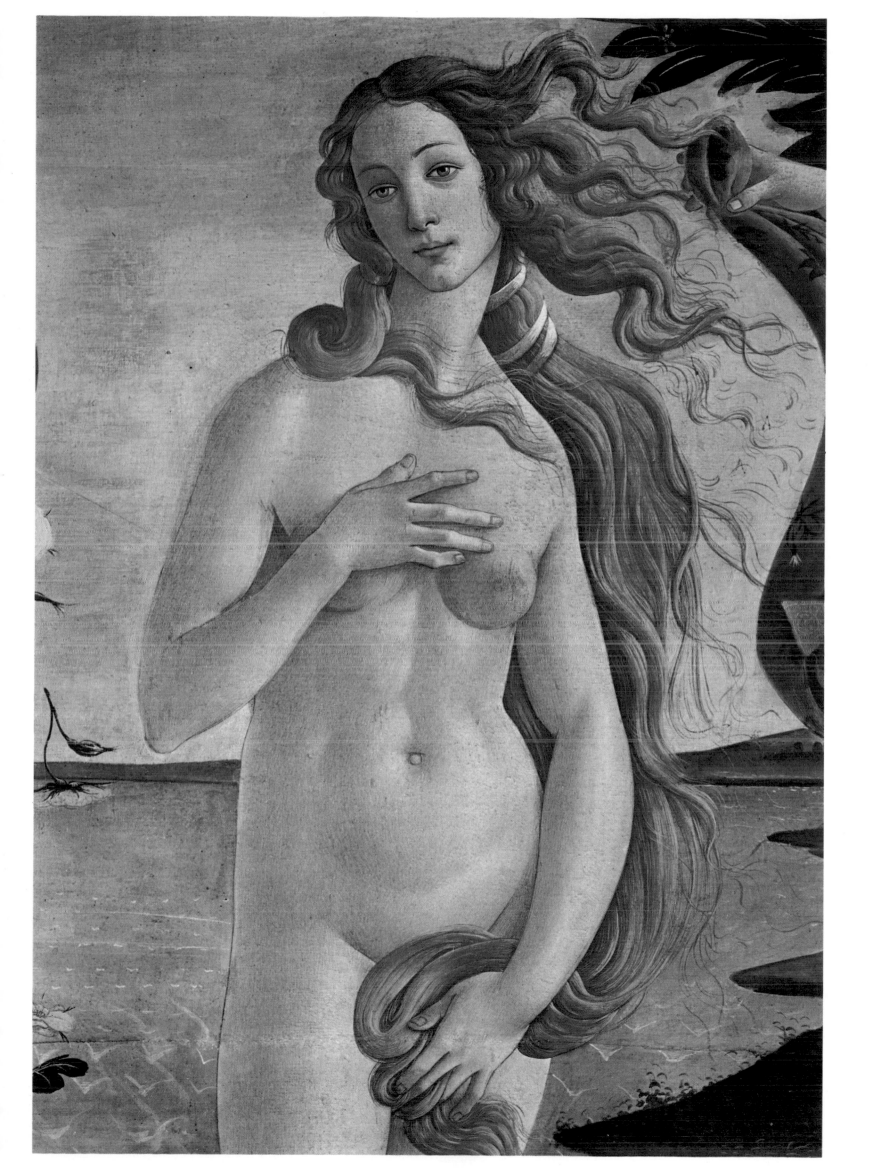

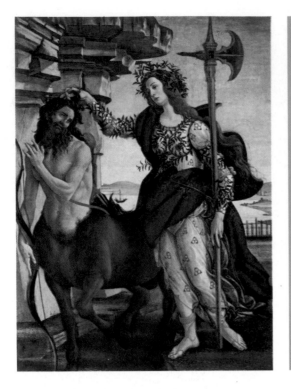

Botticelli: *Pallas and Centaur*, 207 × 148cm, c.1482

Like the *Primavera* and *The Birth of Venus*, the *Pallas and Centaur* was almost certainly painted for Lorenzo di Pierfrancesco de' Medici, as an inventory of 1516 records that it was hanging in his town house in Florence. As no classical legend tells of any meeting between Pallas and this half-human creature, the work is certainly allegorical. An allegory, however, does not necessarily have to be a complex one. The simplicity of the composition in this case argues for a straightforward triumph of reason, associated with Pallas, Goddess of Wisdom, over man's baser self, as represented by the centaur. The Medici device of the three rings was probably simple flattery, but this detail has convinced some art historians that a political message was intended, namely a reference to the Medici peace treaty with Naples in 1480; to these same scholars, the centaur is hostile Naples, and the barely visible boat in the background, an obvious reference to the means of transport between the two cities. Such crude political propaganda is totally out of character with fifteenth-century art, and is more typical of a later period.

haps the most popular paintings in the Uffizi. This popularity can be largely attributed to their blatant sensuality; in *Primavera* the artist has followed Alberti's rather attractive suggestion, put forward in his 1435 treatise, *On Painting*, and depicted the three Graces, 'those three sisters with their hands entwined, laughing and clad in ungirt diaphanous garments', and in *Birth of Venus* he has gone even further and revealed the naked figure of Venus herself. Given the novelty of such large paintings of classical deities in the 1470s, they must have seemed doubly erotic to the public of their time. With so much obvious enjoyment to be derived from the works, it is sometimes hard to imagine the extremes of human ingenuity to which art historians have been led in their attempts at interpretation. The link with Neo-Platonism is suggested by the fact that both paintings belonged to Lorenzo di Pierfrancesco de' Medici, a pupil and

friend of the founding member of the movement in Florence, Marsilio Ficino. This established, it is difficult to proceed any further, for their subtleties of meaning were lost even by the time of Vasari who, writing over seventy years after the *Primavera* was painted, simply referred to it as a 'scene of Venus whom the Graces deck with flowers denoting Spring'. Even if a specific connection with a Neo-Platonic text could be found, how seriously one should take the whole issue is open to question. The mentality behind such works is perhaps no more profound than that found today, which loves complex crossword puzzles or quizzes. Neo-Platonism itself is a misleadingly cold and daunting concept, but – and this is particularly true of its earlier manifestation – it could also accommodate a considerable degree of light-heartedness. Ficino's very first writings had, in fact, advocated a hedonistic life style, and although in later years he would disown these,

Botticelli: *Venus and Mars*, 69 × 173·5cm, 1485–90

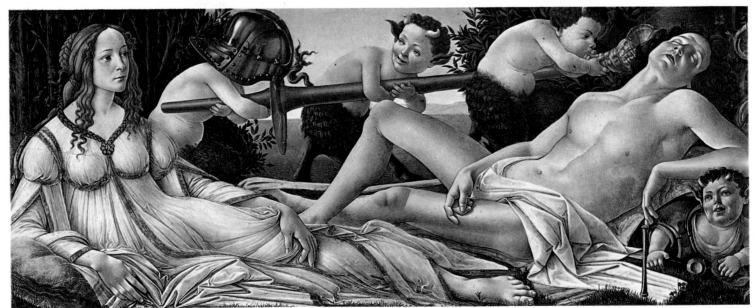

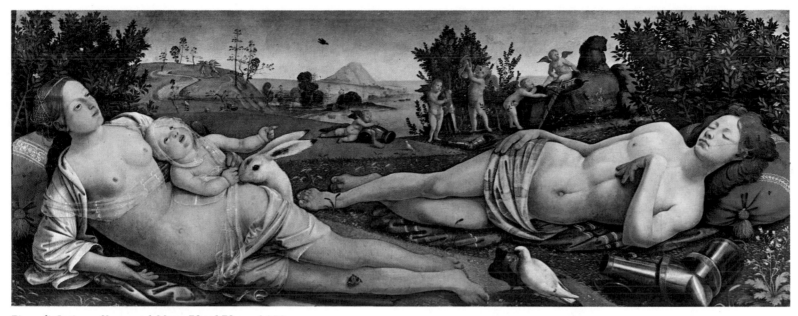

Piero di Cosimo: *Venus and Mars*, 72 × 172cm, 1498

he still developed a philosophy in which pleasure was the dominating principle.

The popular and misleading conception of Platonic love as a purely spiritual emotion overlooks the fact that many of Plato's later followers did by no means dismiss earthly pleasures, but rather tried to reconcile them with heavenly ones. The Neo-Platonists went to ridiculous lengths to devise tripartite formulae that could summarize this reconciliation — in contemporary language the process can be likened to seeing a beautiful girl in the street, and then trying to rationalize one's sexual desires in terms of spiritual ecstasy (hence PULCHRITUDO AMOR VOLUPTAS). The analogy is a crude one, but a certain degree of common sense is required to come to terms with the complexity of language often used. The same is true of so many allegorically-intended paintings of the past, where the seeming intangibility of ideas often hides the most straightforward themes. The temptations of sensuality, for instance, are ubiquitously depicted, and seen in direct confrontation with the more manly, intellectual or

spiritual virtues. The imaginary battle between the senses and the intellect is one that one can still respond to, but in the past this battle involved very real dangers. The pagan world, with all its invitations to hedonism, had to be reconciled with Christianity. Ficino and his circle had been well aware of this, but in spite of their attempts at reconciliation, their subtle and extremely sophisticated arguments were rendered invalid in the face of the crudely fanatical preachings of the Dominican monk, Savonarola; in the language of uncompromising Christian asceticism, this monk violently condemned the sensual paganism advocated by the intellectuals of his time and accused Lorenzo de' Medici of heresy. How profoundly the troubled religious atmosphere of the Renaissance, which eventually led to the Counter-Reformation, affected the personality of the artist, is difficult to establish. Statistics can show that the number of nudes signific-

Saraceni: *Venus and Mars*, 39 × 52cm, c.1608

Botticelli: *Venus and Mars*, 69 × 173·5cm, 1485–90
Piero di Cosimo: *Venus and Mars*, 72 × 172cm, 1498
Saraceni: *Venus and Mars*, 39 × 52cm, c.1608

The story of the love affair between the Goddess of Love and the God of War is typical of a mythological subject which is both allegorical (in this case of the power of love over strength) and lewd. The sleeping Mars in the paintings of Botticelli and Piero di Cosimo is not just symbolic of vanquished strength, but is also a physiological allusion to the fact that a man tends to fall asleep immediately after the exertions of love, while the woman stays pensively awake. In the Botticelli picture, provoking satyrs try to rectify the situation by blowing into the man's ears while flaunting, in the shape of his lance, a very phallic reminder; in Piero di Cosimo's, a rabbit gnaws at Venus's loins as if to suggest her frustration.

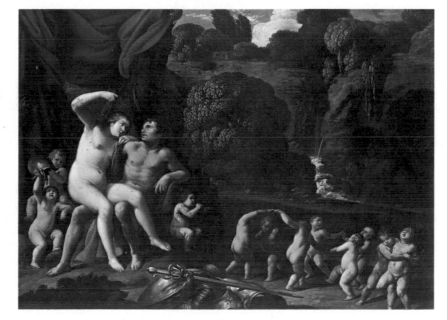

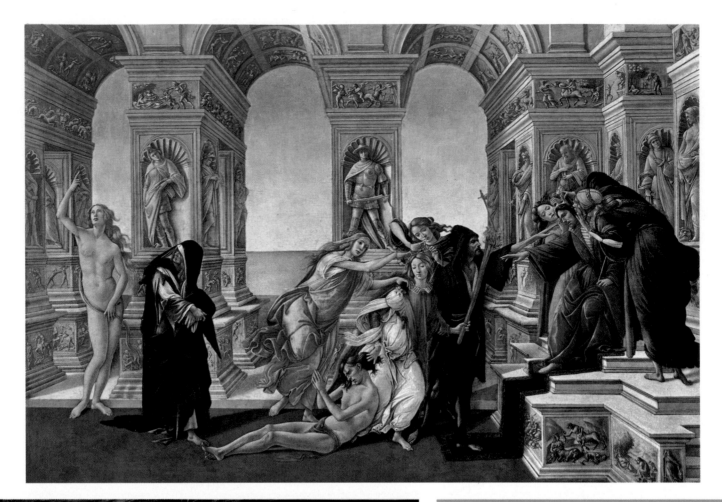

Above **Botticelli:** *Calumny of Apelles,*
62 × 91cm, c.1495

In urging painters to follow classical precedent, Alberti, in his treatise, *On Painting*, recommended as a suitable subject for illustration, an allegory devised by the Greek painter, Apelles, to rebut a rival's accusations that he had been plotting against his king, Ptolemy Philopator. Botticelli closely followed Alberti's description of the work, showing a judge counselled by Ignorance and Suspicion while Calumny, led by Envy and accompanied by Treachery and Deceit, drags in the innocent victim; naked Truth, watched by Remorse, stands on the other side of the painting and points to the sky where true justice dwells. As in Botticelli's other allegories and mythologies, the classical-inspired subject contrasts with its almost medieval treatment; in this case, however, the stiff and restless quality of the composition denies any compensating sensuality. Even the subject is exceptional among Renaissance moralizing pictures, which invariably illustrate, with great relish, the temptations of the flesh.

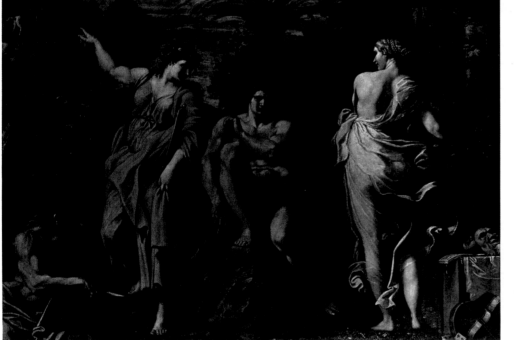

Carracci: *Hercules at the Cross-Roads,* 167 × 237cm, c.1596

antly diminished in the second half of the fifteenth century, but of painters who actually underwent religious crises, there are few examples. One of these might be Botticelli who, according to Vasari, became a committed follower of Savonarola, and when the preacher was burnt at the stake in 1498, never touched a brush again. The last statement is certainly inaccurate, but it is nonetheless true that the artist devoted his later life almost exclusively to religious works,

which acquired a new expressiveness; in the one allegorical work of this later period, the *Calumny of Apelles*, the vocabulary is still pagan, but the spirit is very different and almost hysterical in quality, the nude figure of Truth, a quote from the *Birth of Venus*, being stiff, and, in contrast to the earlier nude, sensually uninviting.

The themes of much allegorical art do reflect contemporary moral dilemmas, but there is a great difference between

OPPOSITE **Botticelli:** *Calumny of Apelles* (detail)

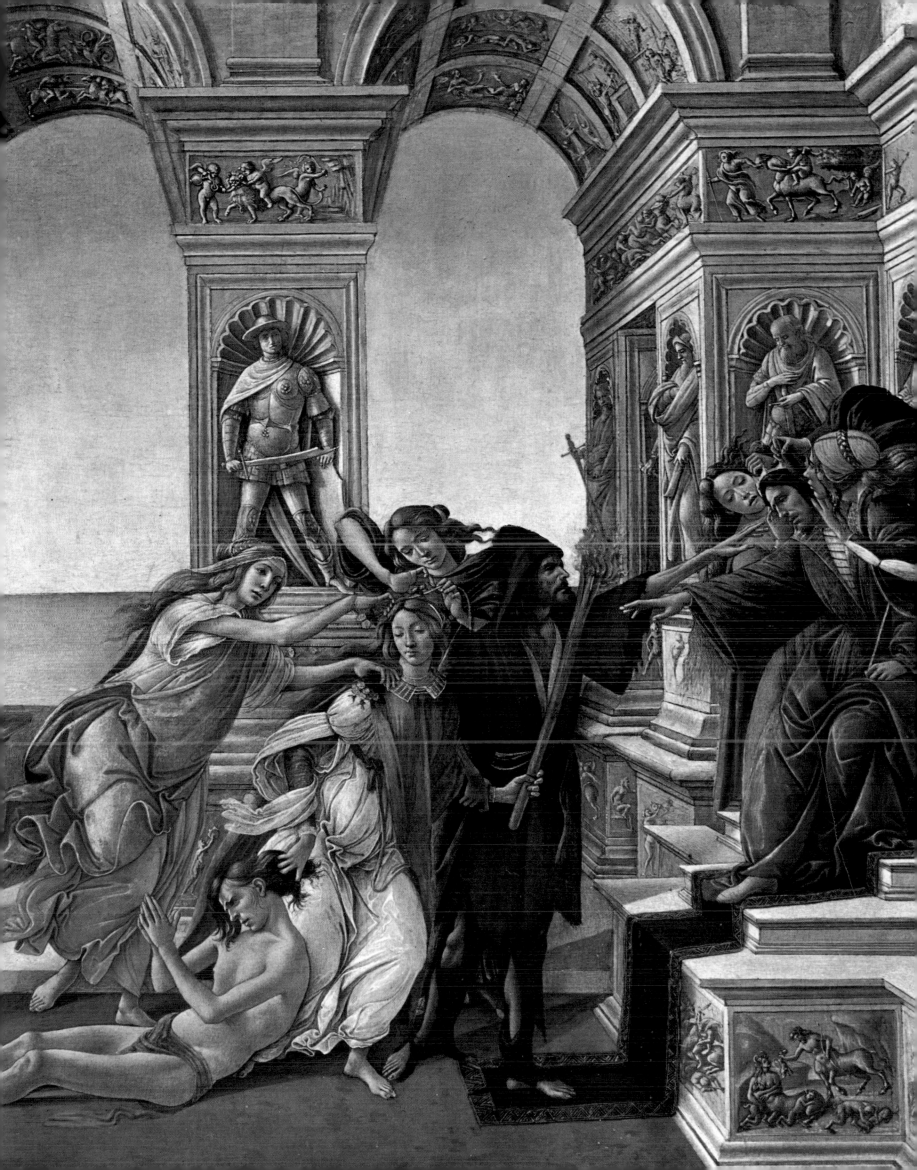

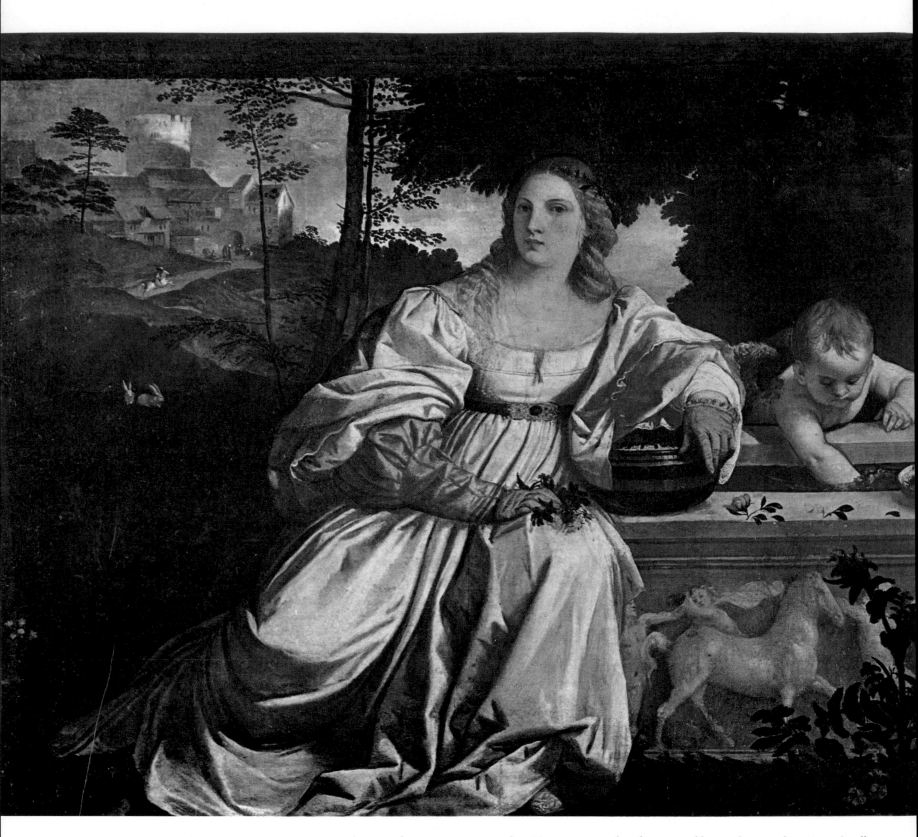

a theme and its treatment. Whereas the near-puritanical tone of Botticelli's *Calumny* seems to imply a strong commitment to the ideas portrayed, in the vast majority of allegorical works, the tone of the painting is totally at variance with the serious argument that it officially presents. Titian's *Sacred and Profane Love* is a case in point. Needless to say, the painting has been shown to expound the most high-minded philosophical principles, but it is certainly a commentary on different types of love. This sort of discussion about the true nature of love became very fashionable in the sixteenth century under the influence of the Neo-Platonists; mention of base physical love was excluded from these discussions, and in Titian's painting this castigation of passion is possibly referred to in the two monochrome scenes on the central sarcophagus, which seem to depict a scene of punishment.

However worthy the type of love advocated in Titian's allegory, the artist was simply catering for a silly fashion, and the fact remains that the naked Venus, representative of Sacred Love, arouses thoughts that are far from Platonic. To be paralleled with Titian's freshness in his portrayal of allegory and mythology are the writings of his greatest friend, Pietro Aretino. Aretino, one of the most controversial figures of his time, is best known for his letters, in which he reveals an infamously malicious wit, and obsession with food and sex. Not a great classical scholar himself, he abhorred pedantry, and his attitude towards the arts (and also Neo-Platonism) was summed up in one of his comments on Michelangelo's *Last Judgement*: 'If Michelangelo desires that his pictures be understood only by the few and learned, I must leave them alone since I do not belong to these.' Aretino's brash and

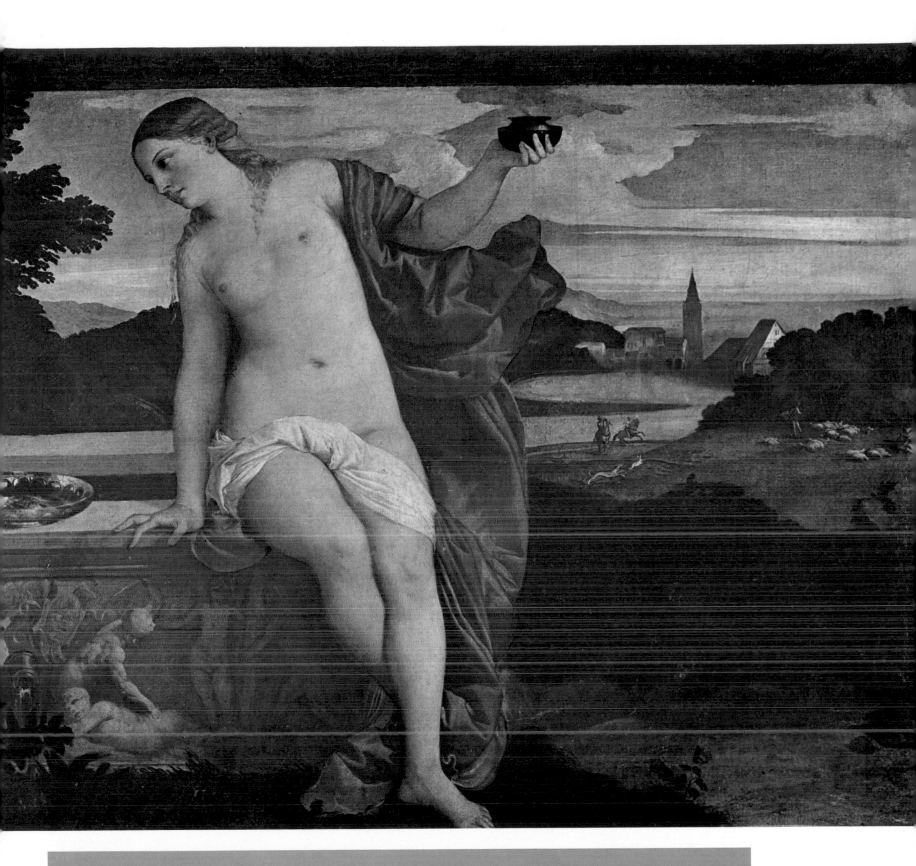

Titian: *Sacred and Profane Love*, 118 × 279cm, c.1514

Venetian painting, with its obvious sensuality in the treatment of colour and light, is the least conducive to scholarly interpretations, and has often undermined some of the more impressive iconographically-minded art historians. The history of critical interpretation of Titian's so-called *Sacred and Profane Love* throws little light on the painting but much on the amount of time which scholars are prepared to waste. The fact that the painting is an allegory cannot seriously be doubted, and those that have done so, seeing in the central figures such disparate characters as Helen of Troy, Medea, Calypso, Sappho, or even Jupiter (disguised as Diana and about to seduce Callisto), have made the greatest fools of themselves. The

theory that the painting can be linked with contemporary discussions on love is by far the most convincing, but it is unnecessary to follow this up with a categorical analysis of every detail. From the escutcheons that appear on the canvas, the work was probably commissioned for the marriage, in 1518, of Niccolò Aurelio to Laura Bagarotto. An allegory of love would thus have been appropriate, and the work was probably much more jovial in intention than is now recognized. The first mention of the work, in Francucci's 1613 description of the Villa Borghese, refers to it simply as 'Beauty Adorned and Unadorned', a title which most captures the salacious suggestion – to be found also in Goya's unclothed and clothed Majas – inherent in the contrast between the two figures.

morally unscrupulous life has little appeal to the prude, and Titian's first serious biographers, Crowe and Cavalcaselle, considered it inconceivable that someone with 'so noble a mind as Titian's should have had anything to do with him'. Such prudery, continuing even to the present day, sadly limits one's understanding of the art of the past; only if one

Left **Correggio:** *The Dream of Antiope,* 190 × 124cm, c.1530
Below **Titian:** *Venus Bandaging the Eyes of Cupid,* 116 × 185cm, c.1565

Many allegorical paintings of the Renaissance were commentaries on love. Correggio's so-called *Dream of Antiope* is first described in a 1627 inventory of the palace at Mantua, as a 'Venus and Cupid who sleeps, and a satyr'. Correggio may well have had in mind the legend described by Ovid of Antiope, the maiden seduced by Jupiter in the form of a satyr, but the central figure has the attributes of Venus, and the painting was almost certainly a pendant to the *School of Love* in the National Gallery of London. A pair of copies of these two paintings, in the collection of Charles I, was referred to as 'Celestial and Earthly Venus'. Corregios painting thus illustrates profane love, but the tone is hardly a condemning one, and it is tempting to consider the notorious Federigo Gonzaga as the original instigator of the commission. Titian's *Venus Bandaging Cupid,* unlike his earlier *Sacred and Profane Love* does not offer any problems of interpretation if one accepts that the artist has merely depicted the process whereby love is blind. So many of these painted commentaries on love should not be taken as seriously as they were once discussed by philosophers, or are now by art historians.

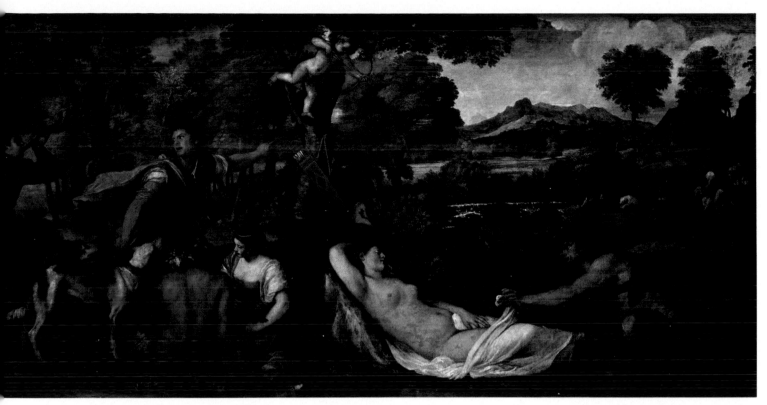

Titian: *Pardo Venus,* 195 × 385cm, 1560

can look at an artist like Titian with the eyes of an Aretino, can one begin to see dry doctrines and abstract theories transformed by paint.

The great divide between humanistic theories of art and the character of the artist should make one wary of having a too intellectual approach towards mythological painting. What was the artist to make of all the erudition which he was meant to display in his works? If he was to attain the stature of a poet, he should have to be as well-read, which, in most cases, he clearly was not, and when commissioned to paint a complex allegory, he was generally compelled to seek advice from a humanist scholar. Very frequently such a scholar, the sort of person on whom Aretino would have piled all his contempt, was instructed to draw up a highly involved programme, from which the artist was not allowed to deviate. Few of these programmes survive, but those that do are hardly conducive to inspired painting. One of these, devised by Paride da Ceresara, humanist adviser to Isabella d'Este at Mantua, was sent, along with a drawing, to the Umbrian painter, Perugino. It is a lengthy document, outlining all the details to be included in the painting, and a short extract gives some idea of its general tone:

> These last (Amoretti) will be smaller than the God Cupid, and will carry neither gold bows nor silver armour, but darts of some baser material, either wood or iron as you please. In order to give full expression to the fable and adorn the scene, the olive tree sacred to Pallas will rise out of the ground at her side, with a shield bearing the head of Medusa, and the owl, which is her emblem, will be seen in the branches of the tree. At the side of Venus her beloved myrtle tree will flower.

Very generously the artist was told that he could reduce the number of figures if necessary, but only if he did not add any-

thing of his 'own invention'. It is easy to understand how the Venetian artist, Giovanni Bellini, likewise commissioned to do a work for Isabella d'Este's *studiolo* at Mantua, never managed to produce anything, and there is evidence that he was very unhappy at the subject imposed on him. In the words of another literary figure, Pietro Bembo, writing to Isabella in 1504, Bellini was a man 'who liked to go his own way in painting'.

A short-cut to employing a humanist scholar, and a method increasingly favoured by painters in the second half of the sixteenth century, was to turn to illustrated editions of the classics, and to a new form of literature, emblematic and iconographical studies, the most famous being Alciati's *Emblemata* (first edition, 1531), and Ripa's *Iconologia* (first edition, 1593). These last books, illustrating maxims like FESTINA LENTE ('hasten slowly') or the symbolical attributes of concepts like Chastity or Fortitude, made allegory very much more accessible, and maintained (especially in the case of Ripa) a great popularity right up to the end of the eighteenth century. The question remains as to how much could a painter assimilate the greater complexities of classical culture were it not for all the humanist advisers and do-it-yourself text books. The demand for the painter to be learned was a fallacy of humanistic art theory, and strongly connected with this fallacy was the assumption that as well as giving pleasure, a primary function of art was to instruct. Even Poussin, one of the few painters who displayed a truly profound knowledge of the classics, nonetheless considered that the aim of all art was 'delectation'.

Amid all the complex issues raised by the relationship between the classics and art, the fact that the classics were also an unending fund of excellent and entertaining stories should certainly not be overlooked. Of all the classical authors Ovid had the greatest appeal for painters, so much so

that the *Metamorphoses*, which appeared in innumerable illustrated editions, became known as 'the painter's bible'. Almost all the greatest artists from the sixteenth to the eighteenth century illustrated scenes from it, and nearly all were united by one common source of inspiration — the very human way in which Ovid presented classical myths. The fantastic transformations forming the basis of the *Metamorphoses* tested an artist's ingenuity, but of greater interest was the psychological perspicacity of an author who showed that behind all life's mysteries were intense feelings to which anybody could respond: sexual desire, frustration, jealousy. While the humanists were discussing, in abstract terms, the nature of love, the *Metamorphoses* offered concrete examples of love in all its guises, from the most lyrical to the crudest. In the past the art lover must have followed the various affairs of the Gods, their marital infidelities, and obsessive desires with that same degree of passionate, almost morbid curiosity with which one now follows the lives of the great film stars; one's own problems and obsessions are reflected and highlighted in a more glamorous world. The art lover of today sees representations of Ovid in a rather different light; generally ignorant of a painting's story, it is too easy for him to see these paintings as completely serious. Many of Ovid's tales are, in contrast, extremely comic. When Mars, for instance, is compromisingly caught between Venus' legs, in full view of the assembled Gods, this becomes, for a long time, 'the best-

Reni: *Fortune*, 188 × 155cm, 1623

Veronese: *Venus and Adonis*, 212 × 191cm

Venus's affairs with both Mars and Adonis are the best known of the amorous interludes of the *Metamorphoses*. Adonis was the son of Myrrha, who gave birth after being transformed into a tree as punishment for an incestuous relationship with her father, Cinyras. Venus, having been grazed by Cupid's arrow while the latter was kissing her, immediately fell in love with the beautiful Adonis: 'She even stayed away from heaven, preferring Adonis to the sky. She used to hold him in her arms, and became his constant companion.' Veronese's painting in Madrid, probably to be identified with the one bought by Velazquez in Venice in 1641, shows this more tender moment of the story, with Venus being very protective towards her lover and looking angrily in the direction of a cupid, whose barking dog might awaken him. A certain degree of humour was obviously intended in the last detail, but it was also a reference to the tragic outcome of the story. Once awakened by the restless dog, Adonis would be reminded of his activities as a huntsman. At a later stage, Venus tried to dissuade him from hunting dangerous animals, but Adonis paid no heed to her advice, and was eventually killed by a boar; he was metamorphosed into an anemone, a beautiful flower of brief duration, and his affair with Venus became symbolic of the frailty of human happiness.

OPPOSITE **Bronzino**: *Venus, Love and Jealousy*, 193 × 139cm, 1545–6

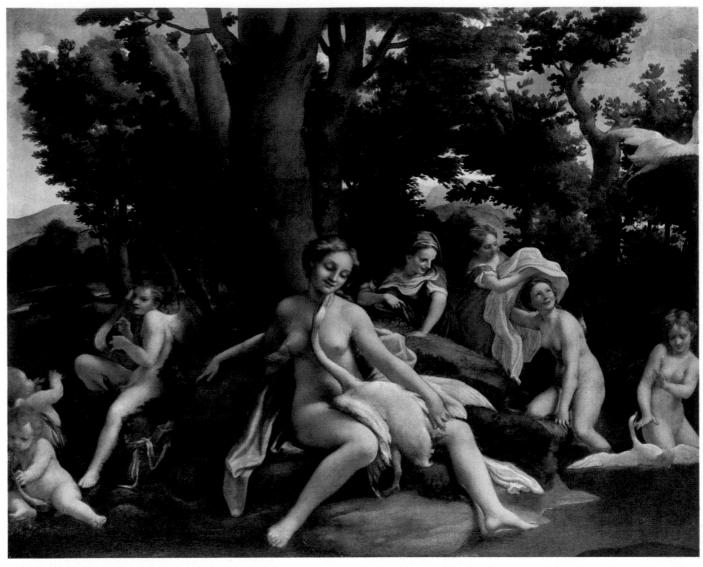

Correggio: *Leda and the Swan,* 152 × 151cm, c.1534

LEFT **Leonardo da Vinci:** *Leda* (copy), 112 × 86cm
BELOW **Tintoretto:** *Leda,* 162 × 218cm, 1580-5

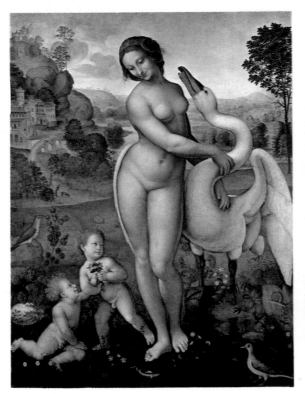

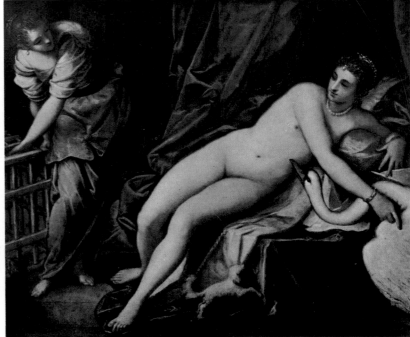

known story in the whole of heaven', and one of the Gods 'prayed that he too might be so shamed'. Humour and eroticism become inextricably linked. The various seductions of Jupiter, perhaps the most popular of all Ovid's themes for painters, provide an opportunity to portray both the ridiculous manifestations of the God, in the form of gold, a cloud, a bull, a swan, while exploiting to the full the lewd suggestions pertaining to these forms. The amorous swan is an amusing concept, but between Leda's legs, the swan is also a particularly long and elastic penis, or again the bull symbolizes the absurd grossness and bestiality of passion, which is funny, terrifying, and exciting all at the same time. The stifled and nervous laughs occasioned by sexual foreplay, captured in such works as Correggio's *Leda and the Swan*, turn humour into bliss, and at times the pleasure could reach orgasmic intensity, as in the same artist's *Io*, where the suggestiveness of the theme of nubile seduction is matched by that of the technique. Titian's eroticism is, in contrast, more blunt, and is often accompanied by a far from coy sense of humour that offers a malicious commentary on the rather unglamorous action portrayed. The combination of passion and humour is particularly offensive to the prude, and again it comes as no surprise that our friends, Crowe and Cavalcaselle, those bastions of nineteenth-century morality, should take Titian to task for replacing, in his later version of *Danaë*, a Cupid with a hideous old woman, avariciously trying to secure the coins aimed in the direction of the maiden's now more exposed vagina.

There is nothing particularly noble in the passions that prevail in Ovid's world, and indeed these passions frequently

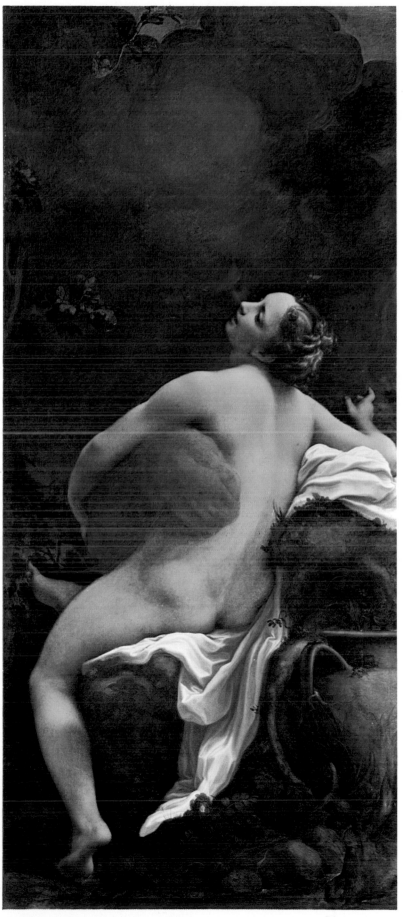

Correggio: *Io*, 163·5 × 74cm, c.1534

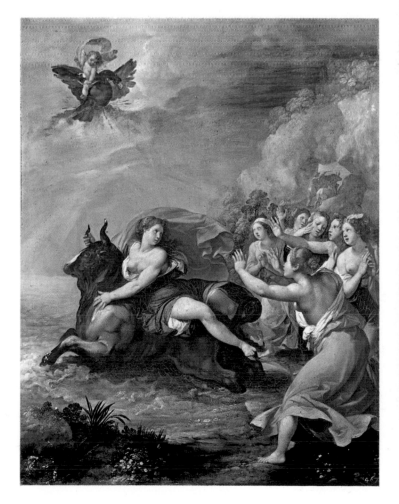

LEFT **Cavalier d'Arpino**: *Rape of Europa*, 57 × 45cm, 1607–8

19

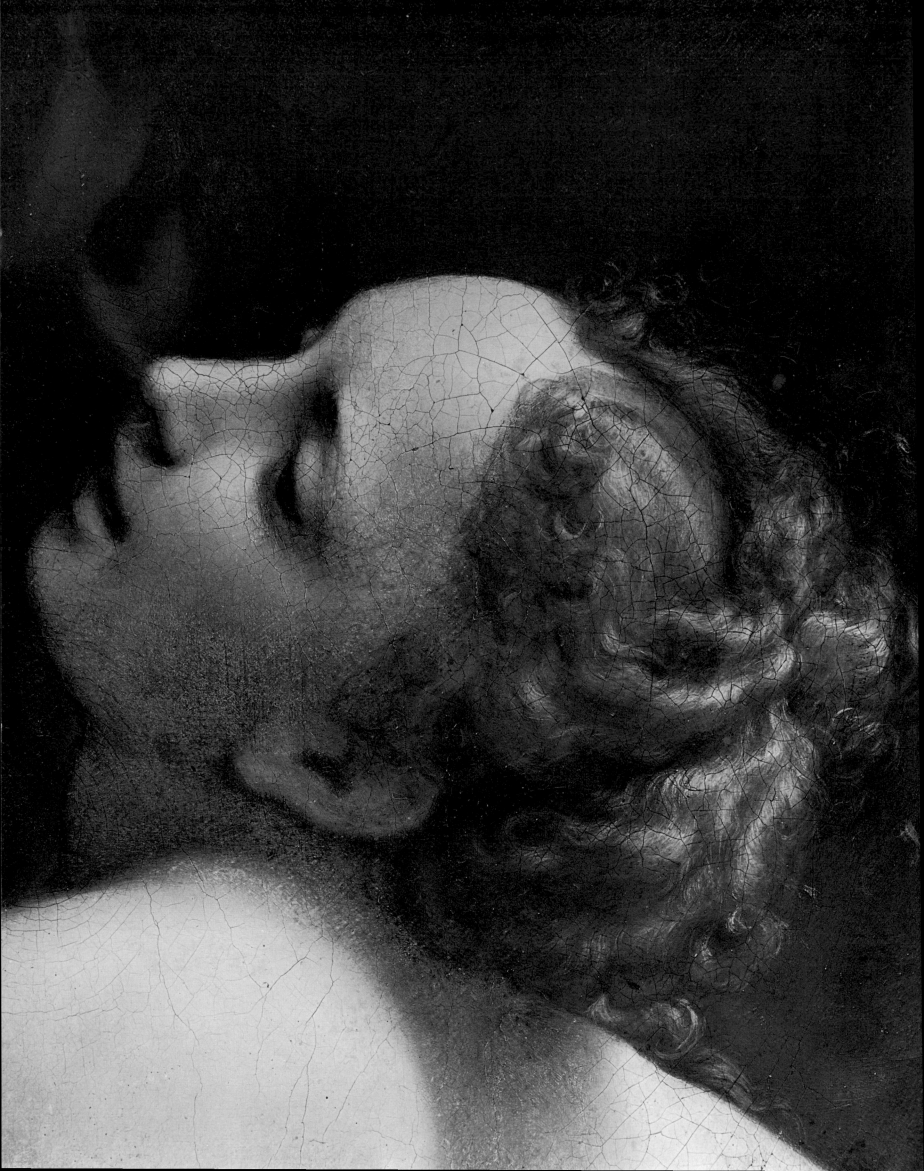

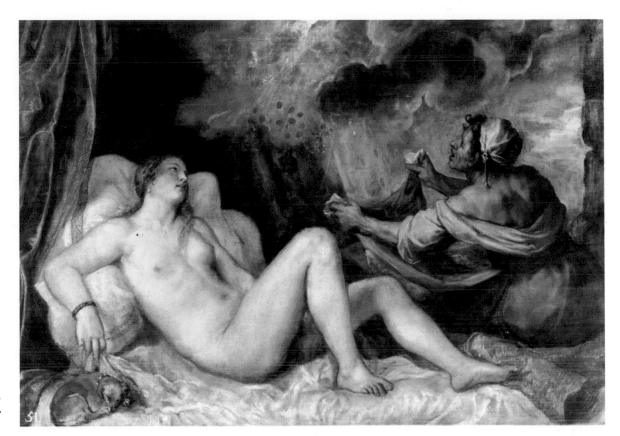

Titian: *Danaë*,
129 × 180cm,
1553–4

contain elements of great cruelty. Many of Ovid's protagonists are virgins, either pushed to their ultimate endurance, like Daphne whose ever more desperate plight gives added frenzy to the chaser, or else revelling in their tantalizing inaccessibility and, like Diana or Atalanta, coolly destroying all those whom they have enchanted with their beauty. The destruction of innocence is often described with sadistic relish: the nymphomaniac naiad Salmacis, for instance, spellbound at the naked beauty of Hermaphroditus, is determined to seduce him. In Spranger's masterfully erotic paint-ing she has just flung aside most of her garments and is teasingly removing a final shoe in readiness to plunge into the pool and 'stroke his unwilling breast, and cling to him, now on this side, and now on that', eventually to bring calamity to them both through her uncontrollable sexual urges. Constantly, in the *Metamorphoses*, people are pitted against each other, placed in bizarre competitions in which the odds generally are uneven. In the case of Hippomenes, compelled through passion to run against the always victorious Atalanta, the penalty for losing is death; in Reni's painting of the subject, the two stripped protagonists are

Right **Rubens:** *Mercury and Argus,*
63 × 87·5cm, 1635–8

When Io was seduced by Jupiter in the form of a cloud, Jupiter's wife, Juno, was immediately suspicious, knowing too well her husband's deceptions. To try and hide his misdeed, Jupiter turned Io into a heifer, which was so beautiful and appealing that Juno demanded it as a present. Juno, still afraid of trickery, however, gave the heifer into the keeping of Argus, famous for his hundred eyes, some of which always remained open when he was asleep. Jupiter, unable to bear Io's sufferings any longer, sent Mercury to try and dispose of her guardian. By playing a reed-pipe and using his magic rod, Mercury managed to put all of Argus' eyes to sleep, and, this achieved, cut off his head. In another version of the story, painted for the Torre de la Parada (see the panel for his *Birth of Venus*), Rubens showed the actual moment of killing; this painting was certainly known to Velazquez, who, in 1659, painted the same subject for the Royal Palace in Madrid, a work in which Argus was turned into a simple herdsman in contemporary attire.

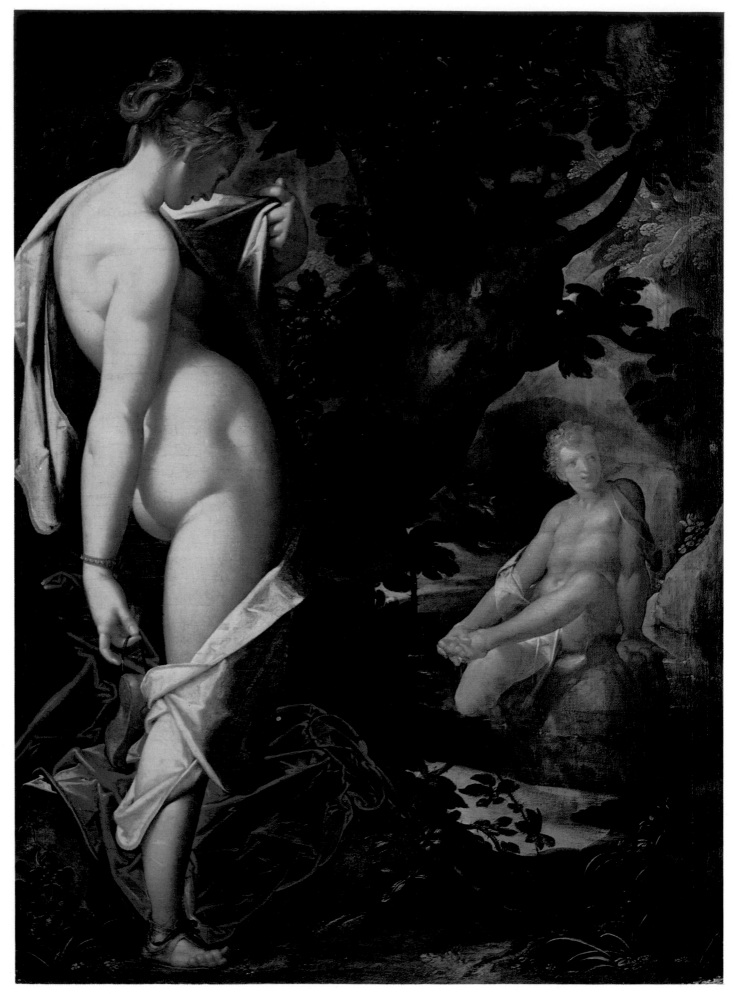

Spranger: *Salmacis and Hermaphroditus.* 110 × 81cm, c.1590

Left **Poussin:** *Apollo and Daphne,* 74 × 100cm, c.1627
Below left **Tiepolo:** *Apollo and Daphne,* 69 × 87cm,
c.1755–60

Apollo, pleased with himself after killing the enormous Python, was challenged by Cupid, who claimed that one of his arrows was more powerful than all those thousand that the God had needed to kill the monster; to prove his point Cupid fired a golden arrow at Apollo, which immediately made him fall in love, and a leaden one at Daphne, which turned her into a determined virgin who scorned all her many suitors. Ovid's description of Apollo's chase after her perfectly conveys the metaphysical pursuit of unrequited love: 'Thus the god and the nymph sped on, one made swift by hope and one by fear; but he who pursued her was swifter, for he was assisted by love's wings'. Eventually Daphne, on seeing her father, the River God Peneios, asked for her beauty to be destroyed, and she was promptly turned into a laurel tree. The sexual excitement of the chase, combined with the imaginative challenge of depicting the sudden transformation (one to which the sculptor, Bernini, most daringly responded), was what made the scene so appealing for artists, and it is doubtful if any of the countless representations of the subject had any moralizing notions about the vanity of pursuing human beauty. Poussin's painting in Munich, however, is characteristically more static, and in his later version in Paris he went against all precedent by representing the earlier moment of the story; for once the subject acquired serious implications

shown at the very moment when Hippomenes miraculously bursts into the lead, a moment of electrifying tension in which his sensuously supple body assumes command in a curious battle of the sexes. Hippomenes was lucky (if only for the time being), but in the case of other mortals, especially those unfortunate enough to anger the Gods, punishment could involve the most terrifying transformations: Arachne was turned into a spider for boasting of her weaving; Marsyas was flayed alive when he challenged Apollo with his music; and Actaeon became a stag simply for having caught a glimpse of the naked Diana and her maidens.

Right **Jordaens:** *Atalanta and Meleager,*
151 × 241cm, c.1628

As a punishment to King Oeneus for not worshipping her, Diana let loose a wild boar in his lands, which terrified the whole community. Eventually Meleager and some other brave youths tried to kill the beast. Joining in the hunt was the girl warrior, Atalanta, who later in the *Metamorphoses* was to show her skill in running. As a huntress, she was no less remarkable, and, in fact, was the first to wound the boar. This feat was noticed by one of her admirers, Meleager, who, when he finally managed to kill the animal, presented her with its head. This story from Ovid, painted by Jordaens on several occasions, was a mythological excuse for one of those hunting scenes so popular in seventeenth-century Flanders, all the terror in Ovid's narrative being replaced by the proud display of a hunting trophy, an image redolent of prosperity. Characteristically, Atalanta, in the painting here, is hardly the lithe elusive virgin of Ovid, but is rather of mature age and form, taking a necessary rest after her understandable exertions.

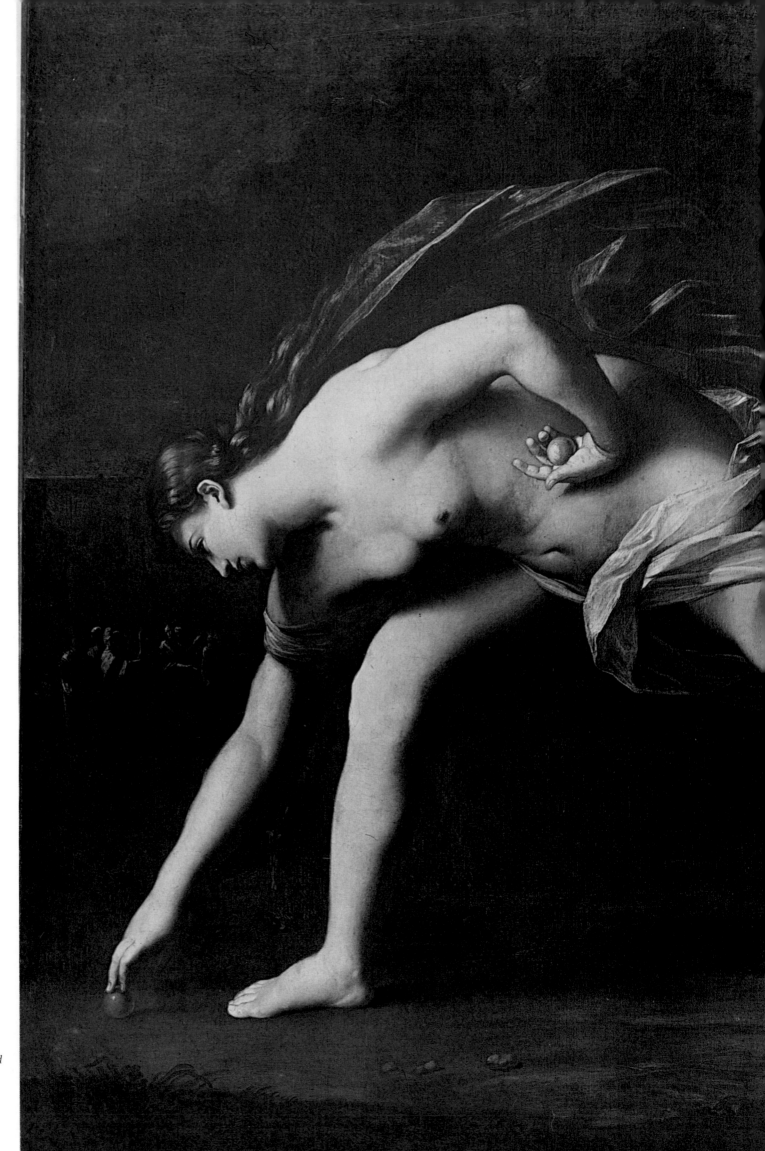

Reni: *Atalanta and Hippomenes*

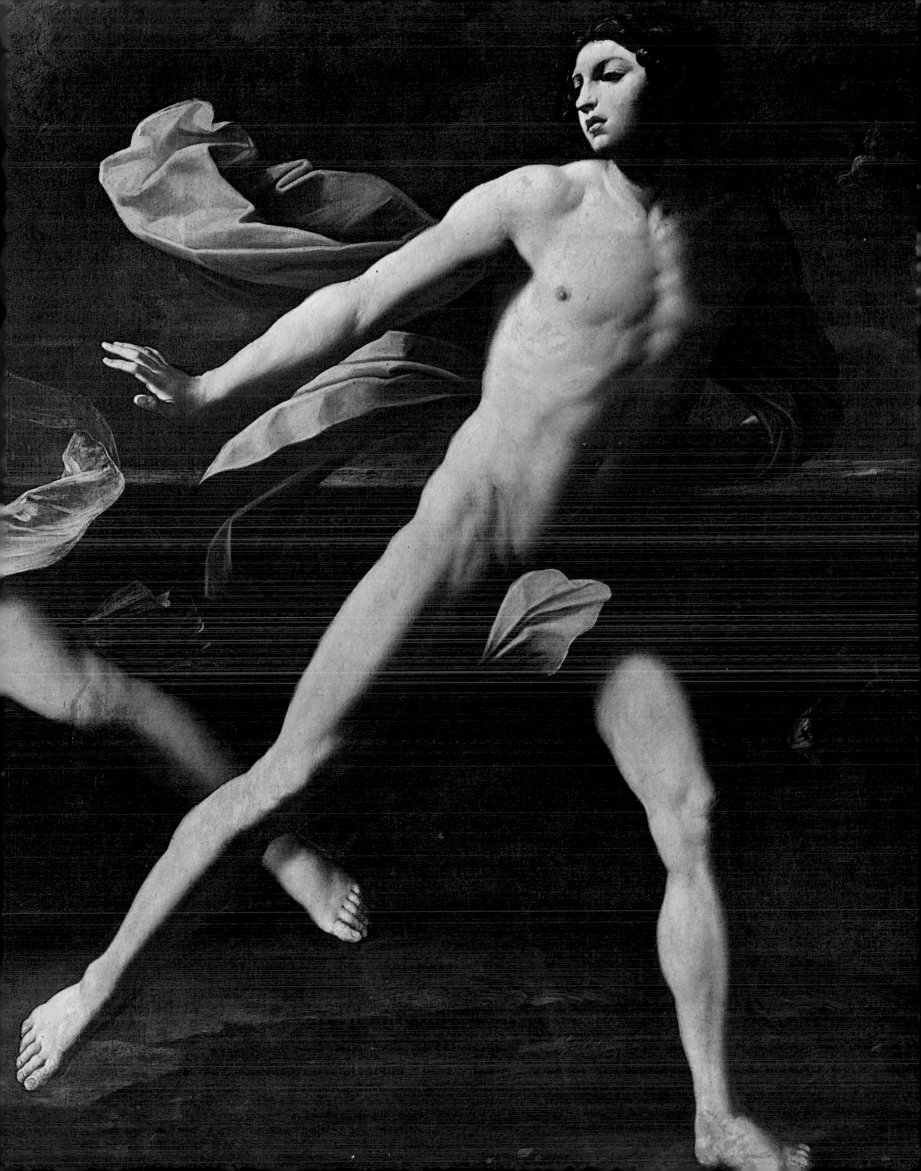

Pages 24–5. **Reni:** *Atalanta and Hippomenes,* 206 × 297cm, c.1620

Atalanta, who had 'features which in a boy would have been called girlish, but in a girl they were like a boy's' is first encountered in the *Metamorphoses* in the Kalydonian boar hunt (see the panel for Jordaens' *Atalanta and Meleager*). Later on in the book, she is revealed as another of Ovid's obstinate virgins, who, in this case, to retain her virginity, insisted that all her suitors take part in a running race against her, the penalty for losing being death. As her athletic prowess was insuperable, Hippomenes, a spectator at one of these contests, wondered why so many young men were prepared to sacrifce their lives; he soon understood why when he saw her strip off her outer garments for the race, and, at the sight of her running, 'the girlish whiteness of her skin . . . flushed as when a scarlet awning, drawn over gleaming marble halls, stains them with a colour not their own', was determined to compete against her himself. Having implored the help of Venus, he was given three golden apples which he was to throw to the ground during the contest. This he did, and distracted by their beauty, Atalanta stooped to pick them up, thus allowing Hippomenes to burst into the lead. Although the couple married as a result of this victory, the story eventually ended in tragedy; Hippomenes, overcome with an 'untimely desire to make love to his wife', did so in a holy place, and as punishment, both of them were turned into lions. The actual race was painted by Rubens as one of the scenes for the Torre de la Parada and, as one would expect from this painter, he captured the sense of frantic urgency and sweat. Reni's version of the subject is very different. Reni, a Bolognese painter who spent some time in Rome, combined an interest in Caravaggio's realism with a more effeminate classicism. His *Atalanta and Hippomenes* is a strangely unreal work, a balletic exercise suggesting sexual tension, appropriate, perhaps, to an artist who was as sexually ambivalent as the heroine portrayed and who notoriously remained a virgin all his life.

Above **Ribera:** *The Flaying of Marsyas,* 202 × 235cm, 1630

Ribera, born near Valencia in 1591, later moved to Italy and settled in the Spanish Viceroyalty of Naples by 1616. Caravaggio's sensational realism and light effects, especially popular with Neapolitan painters, were exploited by Ribera almost to the point of parody, incorporating the love of cruelty and malicious satire peculiar to the Spanish character. Appropriately, when the Viceroy, Ferdinand II, wanted a painter to record the grotesque features of a married woman who had grown an enormous beard, Ribera was chosen. Two versions of the *Flaying of Marsyas* survive; if the reading of the date, 1630, on this painting here is correct, it might well be the work owned by Gaspar Roomer, a Flemish merchant living in Naples, who had one of the most remarkable collections of macabre paintings of his time, including a series by Ribera. Among the high points of this collection was Ribera's *Drunken Silenus,* in which the companion of Bacchus was shown as an absurdly bloated nude, with spindly legs and sunburnt flesh, and a sadly lost portrait of the philosopher Cato, who, in the words of a contemporary, Sandrart, 'lies in his own welling blood after committing suicide and tears his intestines into pieces with his hands'. Gaspar Roomer is exactly the sort of patron to be borne in mind when considering the market for mythology's more horrific scenes.

Titian: *The Flaying of Marsyas,* 213 × 207·5cm, 1570–5

Alongside all the playful seductions and endless promiscuity, the *Metamorphoses* portrays the sense of sadness that the presence of death brings to all this activity, extreme terror and violence of an almost unacceptable degree. Of all these more pungent and horrifying scenes, perhaps the most commonly painted was the flaying of Marsyas, whose piercing screams were described by Ovid in agonizing detail: 'But in spite of his cries the skin was torn off the whole surface of his body: it was all one raw wound. Blood flowed everywhere, his nerves were exposed, unprotected, his veins pulsed with no skin to cover them. It was possible to count his throbbing organs, and the chambers of the lungs, clearly visible within his breast.' It is very appropriate that Titian in a late masterpiece should have depicted this subject, for Ovid's description of the fate of Marsyas could equally be applied to the technique of the artist's late years, in which

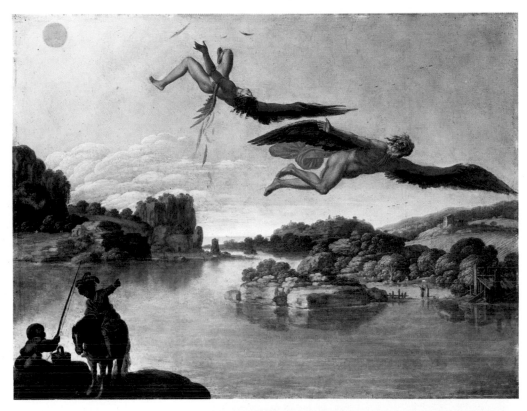

all unnecessary detail has itself been stripped away to reveal a rawness as uncomfortable as Marsyas' exposed wounds. In *The Flaying of Marsyas*, the unfortunate body hangs upside down like Rembrandt's study of a meat carcass, and the horror of the scene is heightened by the cool detachment of the onlookers, and the dog which calmly laps up the fallen blood. This last detail is humour at its blackest. Today's art

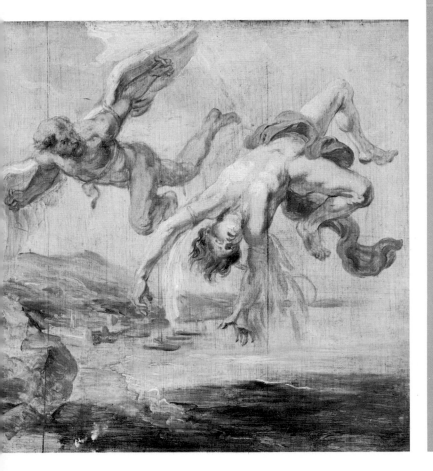

Above **Saraceni:** *The Fall of Icarus*, 41 × 53cm, c.1608
Left **Rubens:** *The Fall of Icarus*, 27 × 27cm, 1636–8

The famous architect Daedalus, tired of the island of Crete but prevented by the sea from leaving, invented some wings made of feathers and wax, which he used to fly away; in his flight he was accompanied by his son, Icarus, who, in spite of his father's warning, flew so close to the sun that the wax melted. The well-known story from Ovid has come to signify the sudden reversal of fortune liable to affect those who rise too quickly to too high a position. Saraceni's painting was one of a series of six scenes from the *Metamorphoses* which were originally in the Palazzo del Giardino in Parma; three of them illustrated the Icarus story, from the moment of departure to the burial of Icarus by his anguished father, cursing his invention. Saraceni, a Venetian painter who settled in Rome in about 1598, came strongly under the influence of the German painter, Elsheimer, who revolutionized the history of landscape painting through his detailed study of light effects. Many of Saraceni's subject paintings were an excuse to portray nature, which, like the law of gravity, was shown to triumph over humanity, its enormity only intensifying the tragedy of man. Rubens, in his depiction of the Icarus story for the Torre de la Parada, was, in contrast, more interested in a physiological study of terror, and the high viewpoint from which this scene is recorded, emotionally involves the spectator himself. More original was Bruegel's version of the subject, where Icarus is literally a mere drop in the ocean. Bruegel took a hint from Ovid's narrative: 'Some fisher, perhaps plying his quivering rod, some shepherd leaning on his staff, or a peasant bent over his plough handle, caught sight of them as they flew past, and stood still in astonishment.' In Bruegel's painting the incident is already over, and the men go back to work.

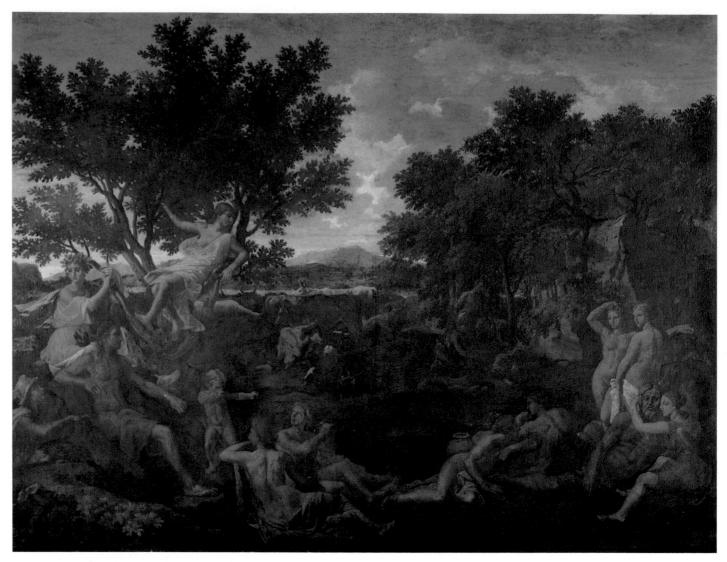

Poussin: *Apollo and Daphne*, 155 × 200cm, 1664

lover is not so enamoured of scenes of this sort, but the art lover of the past had no such qualms. A painting like Titian's *Marsyas* had an appeal which cannot be explained away in terms of Aristotle's mysterious concept of *catharsis* ('by means of pity and fear bringing about the purgation of such emotions'); quite simply, the work catered for enthusiasts of the violently macabre, a market which today is largely cornered by the cinema.

With all the straightforward eroticism and violence in Ovid, it was inevitable that justifications for the author's popularity had to be found. Editions of Ovid appeared in which morals, or, in some cases, far-fetched allegories, were drawn

Left **Poussin:** *The Kingdom of Flora*, 131 × 181cm, 1631

This painting shows how Poussin's interpretation of Ovid was radically different from that of other artists, and how, even at this relatively early date, he took an interest in the more profound significance of the stories in the *Metamorphoses*. The work depicts all the characters in the book who were changed into flowers, including Ajax who turned into a hyacinthus on committing suicide; Clytie, transformed into a violet after staring constantly at the sun-god; Narcissus who wilted away into a daisy through being in love with his reflection; and so on. Poussin and his friends had a great interest in the cultivation of flowers, but *The Kingdom of Flora* not only reflects their love of the natural sciences, but also of speculative philosophy; although the stories referred to in the painting are of tragic occurrences, the overall mood is festive for the transformation into flowers symbolizes resurrection, and the presence of Apollo, source of life in plants, and of Priapus, god of gardens and fertility, further the image of regeneration.

from the various stories. Only one great painter managed to create out of all these involved interpretations a work of genuine profundity. Poussin's *Apollo and Daphne*, his last mythology and left unfinished a year before his death, clearly differs from the usual representations of a rather distraught female sprouting branches. Instead, the artist has chosen an earlier moment in the story, when Cupid fires a golden arrow at Apollo, who is wounded with love, and a leaden one at Daphne, who in consequence has to spurn his affections. The serious tone of the painting and the haunting static quality of its composition do not, however, suggest a straightforward narrative picture. It must be remembered that the *Metamorphoses* begins with an account of how the universe began, how a 'shapeless unco-ordinated mass' was moulded into form by the various elements; the book subsequently deals with transformations that further explain the origins of a myriad of natural details (for example, Daphne turned into a laurel tree). This type of speculative enquiry into the origins of the universe was precisely what interested Poussin in his *Apollo and Daphne*, but although he stuck quite closely to the narrative details of Ovid's text, he was obliged to turn

to other authors who dealt with such theoretical problems at greater length. The Greek philosopher, Heraclitus, for instance, considered that the world was based on a harmony created from tensions between opposites, in particular between hot and cold, dry and moist. Many of his ideas were taken up in later antiquity by the Stoics who, at a time when the traditional myths were challenged as being contrary to reason, gave them new life by seeing them as allegories of the physical phenomena of the universe. Ovid himself could be interpreted in this way, and a pantheistic interpretation of the Apollo and Daphne story was, in fact, included in a late sixteenth-century poetical treatise, *Il Sogno overo delle Poesie* (1590) by Gabriele Zinano. Whatever the specific sources of Poussin's painting, his affiliation with Stoicism was extremely well-known. In the *Apollo and Daphne* he has divided the picture into two distinct halves so as to emphasize the contrast between the fertilizing power of Apollo and the obstinate virginity of Daphne; accordingly, all the symbols of life and fertility are included on the left-hand side of the picture, and on the right those of death and sterility. Poussin is not an easy painter. Many of his early works had shown a deep

Rubens: *The Judgement of Paris*, 145 × 190cm, 1632–5

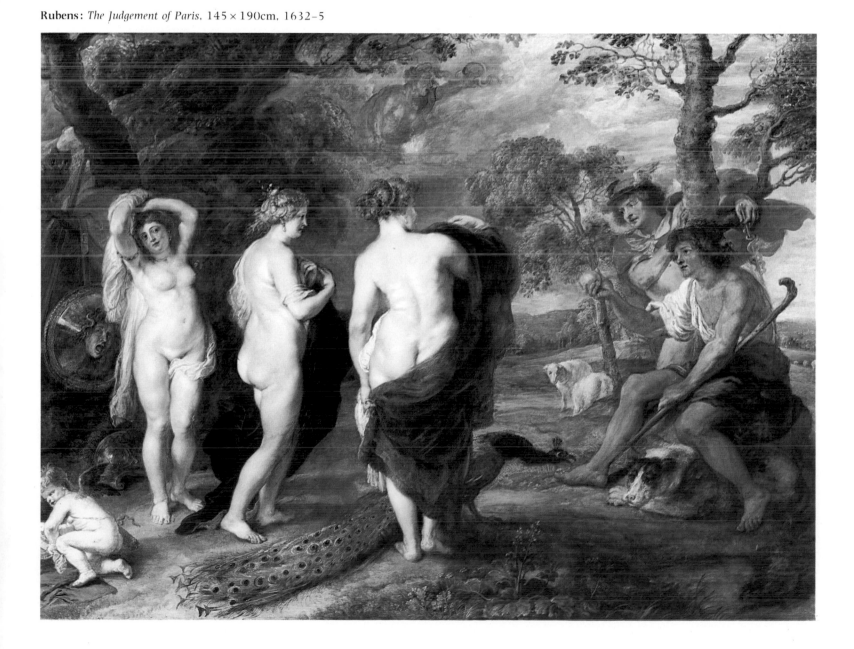

Mythological Painting: **El Greco**

Below **El Greco:** *Laocoön*, 137 × 172cm, c.1614
Right **Barocci:** *Aeneas Fleeing from Troy* (detail), 1598

The Greeks' sally into Troy, while hidden in a wooden horse, is probably the most famous incident in the whole history of war. Previous to the actual attack, the Trojans had been warned of the dangers of the horse by the priest Lacocoön, but few paid any attention to him. As a punishment from those gods who were on the side of the Greeks, two enormous seasnakes emerged from the sea and killed Lacocoön and his two sons. The scene was the subject of one of the most influential hellenistic sculptures, but few painted it. El Greco's canvas in Washington, showing in the background the wooden horse advancing towards the Visagra Gate in Toledo, must have had an allegorical intention which would only have been appreciated by the small intellectual community of the artist's adopted city; the figure of Laocoön probably represented Bartolomé Carranza, at one time the Archbishop of Toledo, an enlightened religious reformer who was put in prison for eighteen years by the Inquisition. Barocci's painting of a scene from the actual sack of the city, is, in contrast, purely narrative. The moment chosen by the artist is when Aeneas, eventually to found Rome, carries his father out of the burning city — an exciting moment and a poignant example of filial devotion.

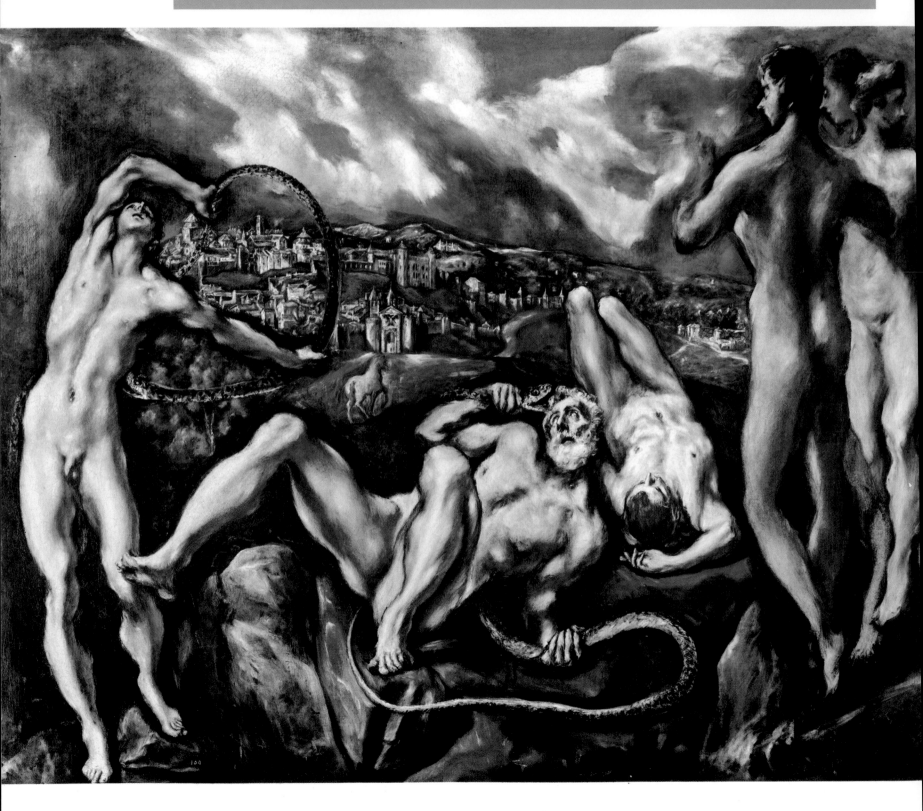

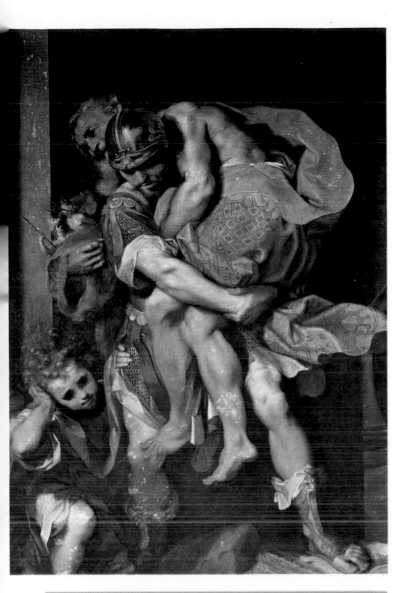

respect for the more colourful and sensual art of Titian, and some like the *Sleeping Venus* had even been erotic; in later life this side to his nature was gradually suppressed until eventually painting itself became a philosophical enquiry, a singularly precise statement, but saved from dryness by a less easy to define lyricism. His late mythologies act as a salutary reminder that classical myths can also encompass some of the more abstract areas of human experience.

While few people are familiar with Ovid today, the legends of Troy and its war must be the best known and loved of all the stories from classical mythology. The incident that sparked off the war, when Paris was made to adjudicate in a nude beauty competition between the three goddesses, Juno, Venus and Minerva, again unleashed painters' more sensual imaginations, giving them an excuse to portray an attractive display of breasts and buttocks from a variety of angles. At the point where Homer takes up the story, however, painters of the Renaissance and Baroque seem to have cooled in their ardour. In comparison to the wealth of inspiration that the *Iliad* and the *Odyssey* gave to music and literature, Homeric subjects in oil painting are surprisingly infrequent. When Tiepolo, in 1757, painted a whole room in the Villa Valmarana with scenes from the *Iliad*, the choice of theme was thus quite original; even so, he chose the quieter moments of the epic, and ones in which there was a strong female interest. The desire to depict the more spectacular aspects of

Pages 32–3. **Rubens:** *Angelica and the Hermit*, 43 × 66cm, 1620–5
Right **Ingres:** *Angelica*, 97 × 75cm, 1819

Ariosto's *Orlando Furioso* shows how humans are chiefly motivated by the promise of love. Angelica is one of the most sought-after women in the book, yet she spurns all her would-be lovers, and it is the unobtainable nature of her beauty which finally unleashes Orlando's madness. Two soldiers engage in brutal combat over their mutual and obsessive love for her, but as she has little admiration for either of them, she runs away and thinks she has found safe refuge in the company of a venerable-looking hermit. The sight of her immediately gives the old man an erection, and through his spells, she is put into an enchanted sleep. Rubens, in a rare depiction of this episode, humorously shows the frustrated hermit voyeuristically uncovering the sleeping Angelica, and the artist might well have had in mind Jupiter's seduction of Antiope. Eventually Angelica escapes, only to be chained to a rock, and at the mercy of a sea-monster, Orca. From this plight, more frequently depicted in art, she is saved by the knight, Ruggiero, who takes her away on the back of a flying horse; he himself then wants to ravish her by now naked body, an incident amusingly portrayed in a painting in the Villa Medici at Petraia, in which the knight is seen hurryingly removing his armour. Escaping yet again, Angelica eventually encounters a wounded moor, Medoro, who finally conquers her seemingly indomitable heart. This last interlude was by far the most commonly painted scene from the poem, and in particular the couple's honeymoon in idyllic pastoral surroundings, where they carve each other's names on the trees. No longer the symbol of elusive beauty, at this stage Angelica virtually disappears from Ariosto's narrative.

OVERLEAF **Rubens:** *Angelica and the Hermit*, 48 × 66cm, 1620–5

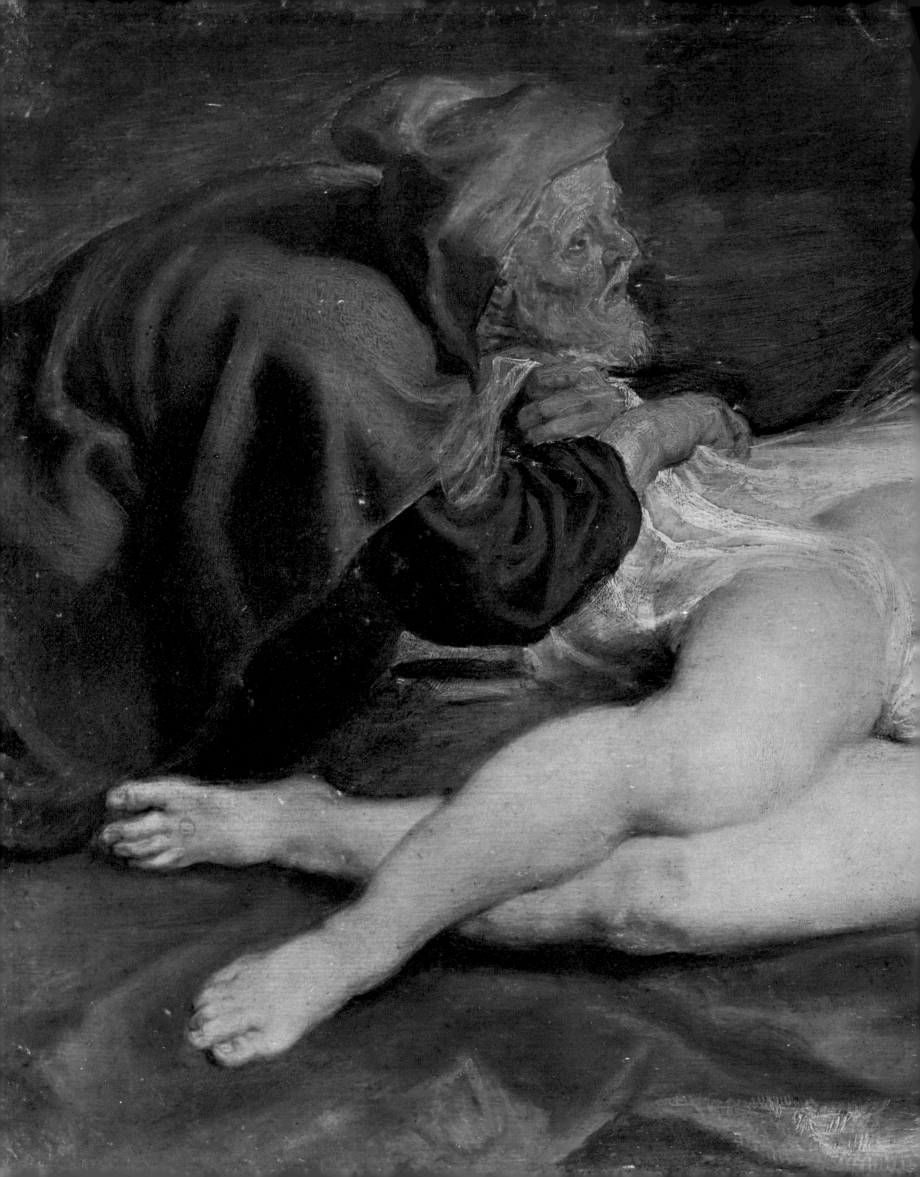

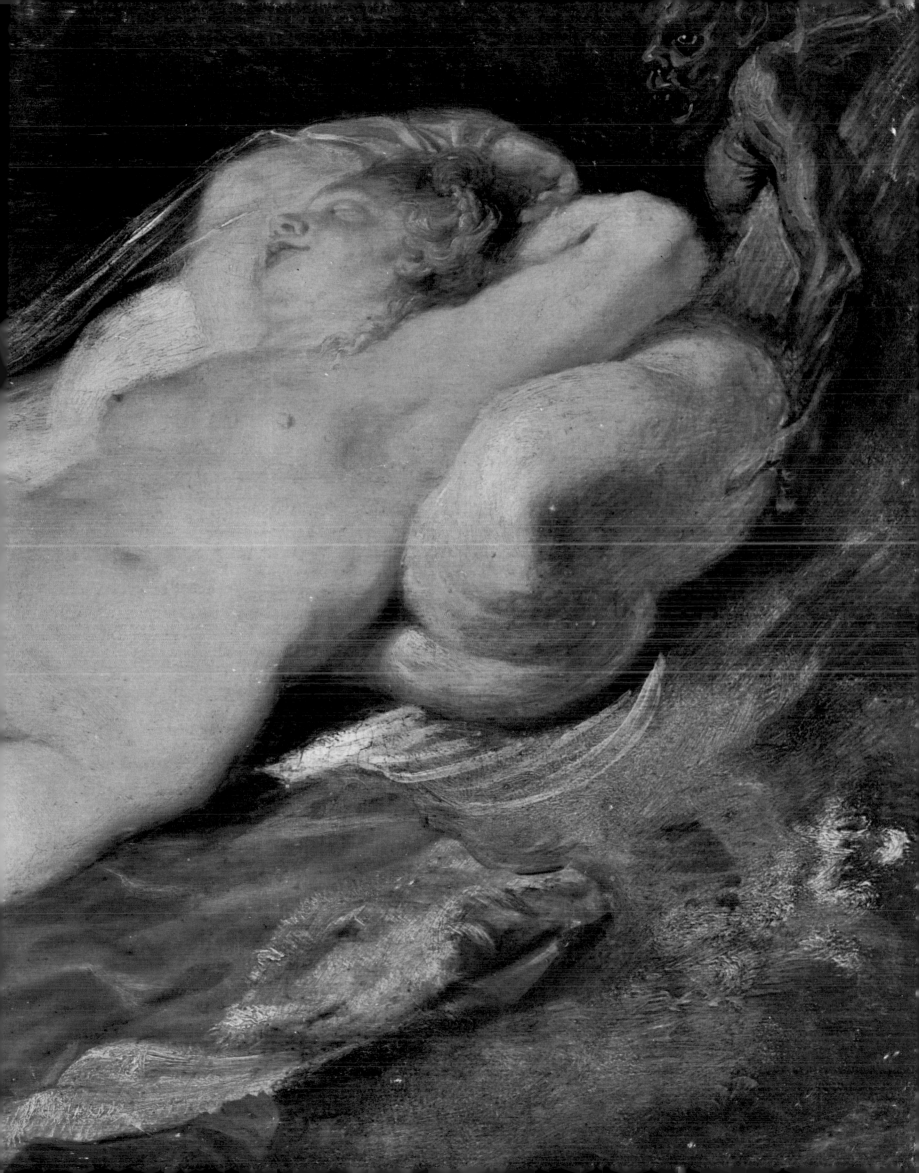

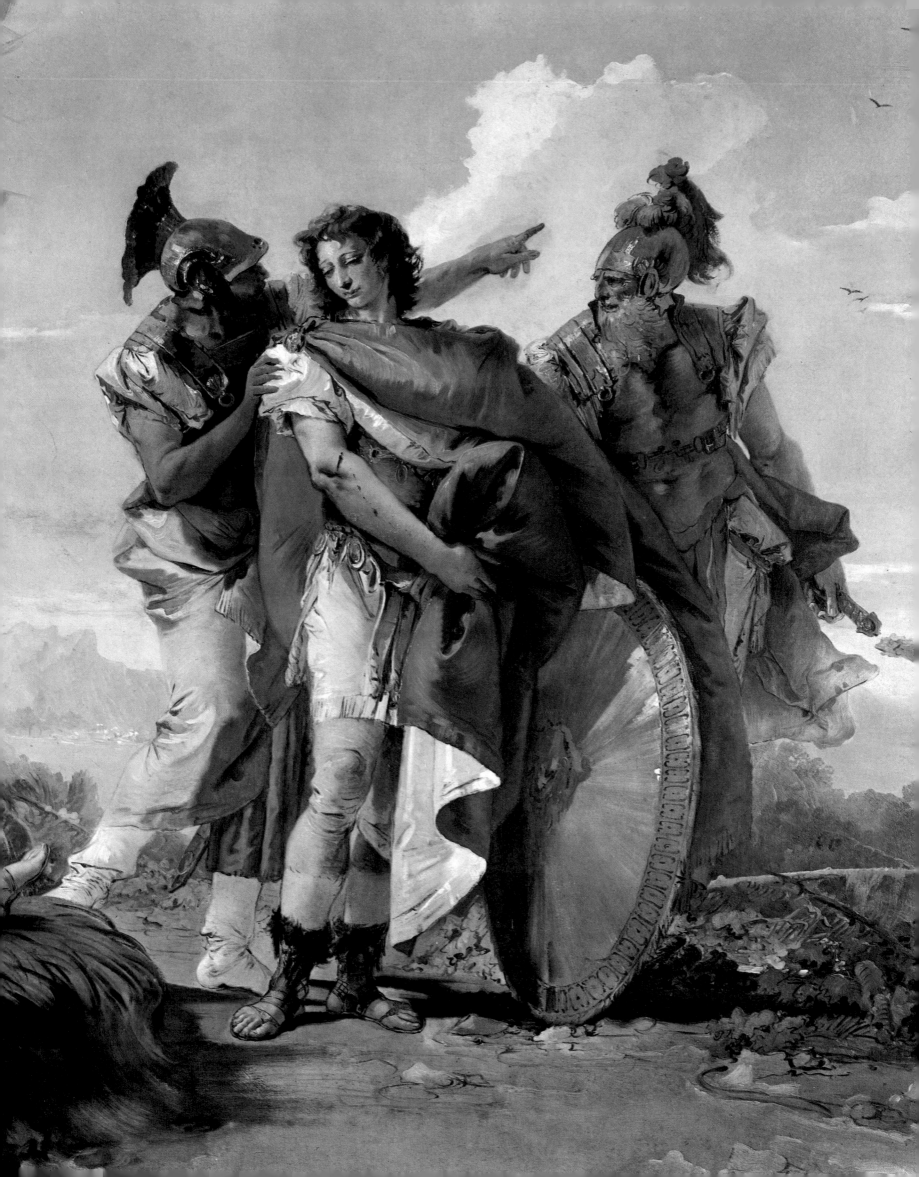

Left **Tiepolo:** *Rinaldo Abandoning Armida*, detail, 1745

In Tasso's *Gerusalemme Liberata*, the enchantress Armida, a figured based, like Ariosto's Alcina, on Homer's Circe, is persuaded by a sorcerer in league with the Saracens to seduce the Christian soldier, Rinaldo. Armida falls genuinely in love with him, and the two have a brief flirtation in her magical garden; already, though, two of Rinaldo's fellow soldiers have been sent to look for him, and, their mission accomplished, Rinaldo is made to remember Christian duty and to abandon his lover. The eighteenth-century Venetian painter, G. B. Tiepolo, seems to have had a particular affection for this story and painted it on several occasions, most famously in four canvases now in Chicago, and in a frescoed room in the Villa Valmarana near Vicenza (c.1557). The earlier series was more precious and decorative, but in comparison to other versions of the story by his contemporaries, Tiepolo gave a genuinely moving interpretation to a by then over-exposed poetic text. This emotional quality is more noticeable still in the Villa Valmarana frescoes, where the theme of thwarted love is also extended to the room with scenes from Homer's Iliad.

war seems largely to have been satisfied by painting either scenes from classical history rather than legend, or battle scenes without any story at all. When Virgil takes over from Homer, when the wanderings of the Trojan Aeneas eventually bring the legends right up to the founding of Rome, the situation in painting remains virtually the same; again it is a lyrical interlude — Aeneas' brief flirtation with Dido, Queen of Carthage — that held a greater appeal for painters than all the bombast of military intrigue.

In the sixteenth century two contemporary Italian epics threatened to usurp the popularity of both Homer and Virgil, and certainly managed to attract more successfully the attention of painters for the next two hundred years. Ariosto's *Orlando Furioso* (first edition, 1516) and Tasso's *Gerusalemme Liberata* (first edition, 1581), both greatly dependent on their classical forebears, dealt with the early struggles of Christianity against the Infidels, and were clearly meant to reflect the Moorish threat of their own time. Ariosto's epic was openly intended as entertainment, and to this end it relied heavily on a multitude of incident and range of tone. By Tasso's time, the need to reinforce the virtues of Christianity had noticeably intensified; both this need, and the clinical paranoia from which the author suffered, made him doubly anxious not to anger the Inquisition, to whom he constantly submitted passages of his still unpublished epic for approval. Tasso intended to improve on Ariosto by cutting out much of the distracting detail, especially the more light-hearted and profane elements, and to create a more unified work of art. Hints that his serious intentions were combined with a failure to live up to his ideals in practice, are provided in the introduction to his earlier poem, *Rinaldo* (1562), in which he says that he has not followed Aristotle's strictest

Rubens: *Garden of Love*, 198 × 283 cm

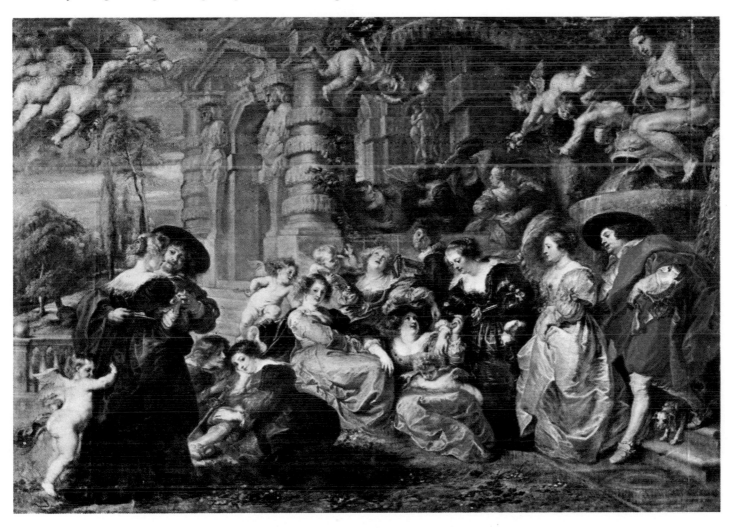

rules, only those which do not spoil the reader's pleasure. Inevitably, those scenes of love that made their way into the *Gerusalemme Liberata* were those that most captured the popular imagination, and, when not included in the later *Gerusalemme Conquistata*, the result is a very dry and lifeless work. In the earlier epic the author had been especially careful to give these scenes a moral significance, but one feels that a sense of Christian justification compensated somehow for the constant amorous frustrations of the protagonists. This was a theme closely echoed in Tasso's own life. In the famous interlude of Rinaldo and Armida, where no moral doctrine could justify the pure physicality of the passions involved, a sense of duty is eventually made to triumph over love; so much, however, does Tasso revel in describing the temptations of Armida's enchanted garden, that one can have little faith in the moral alternative. Tasso's detailed and ecstatic description of the garden gave painters perfect material, and

their preference for this scene over any other in the epic emphasizes yet again the pervasive pull of the senses.

The image of a lush and seductive garden, like that of Armida's, has always been associated with amorous activity. Venus herself, as shown in Titian's *Bacchanal of the Andrians*, had her own special garden, and this classical image was reflected in the secret gardens of the Middle Ages. Rubens' *Garden of Love* follows in this same tradition, but made more real by the inclusion of the artist and his new wife, Hélène Fourment; in another tribute of his love towards her, he even changed the setting to his own garden at Antwerp, a clear indication that the intimations of an earthly paradise, which classical imagery often conveys, can be rendered in purely contemporary terms. The experience of looking at nature, whether tamed or not, conversely may put one in a frame of mind, in which classical visions are more easily imagined. This is an important point, for it will be noted that,

Piero di Cosimo: *Mythological Scene*, 65 × 183cm

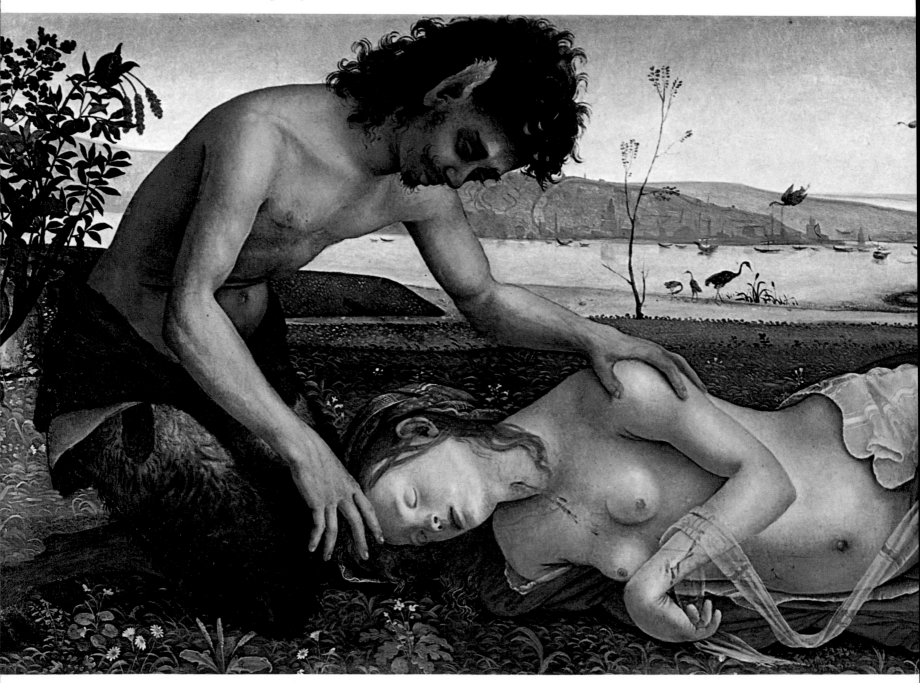

with one exception, all the paintings reproduced in this book have a landscape setting, which sometimes dominates the human element completely. Mythological and landscape painting, the two opposite poles on the humanistic scale, merge, ironically, together.

One of the first painters to speculate seriously on what landscape in antiquity must have looked like, was the eccentric Florentine painter of the fifteenth century, Piero di Cosimo. The legends surrounding an artist's character are often built around an interpretation of his paintings, but it is difficult to get away from Vasari's entertaining account of Piero di Cosimo as a savage recluse who despised all civilized values, hated the sound of church bells and the chanting of monks, survived on an exclusive diet of hard-boiled eggs prepared in great numbers in advance, and whose life-style was, in short, 'more bestial than human'. Piero was constantly fascinated by the primitive appearance of the ancient world, and his vision of nature was extremely individual. It

Perugino: *Apollo and Marsyas,* 39 × 29cm

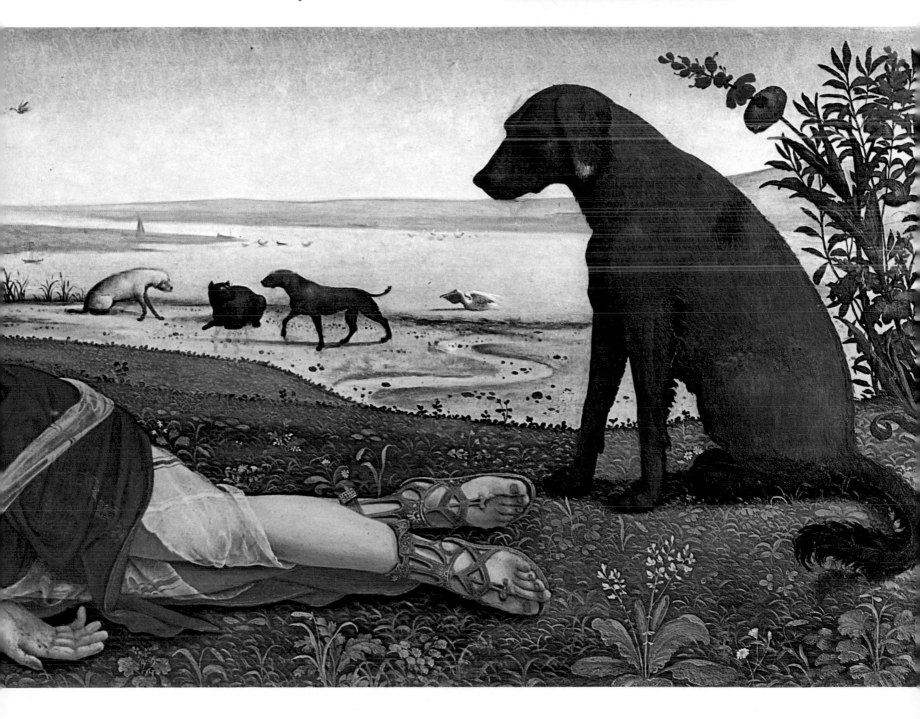

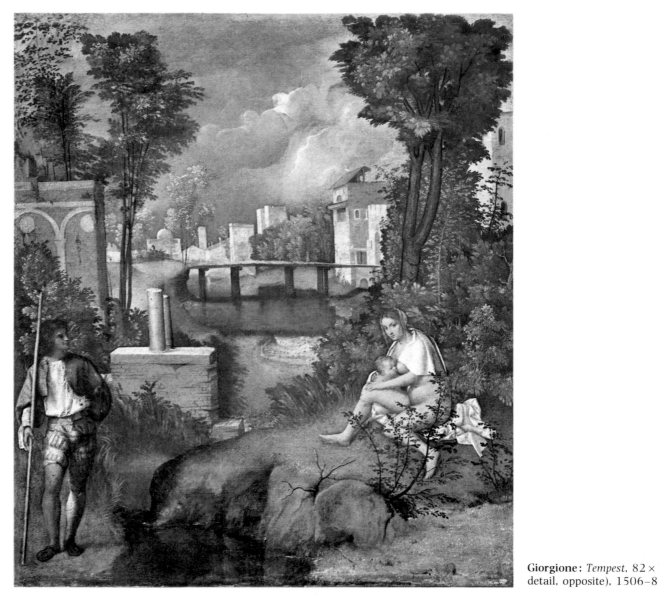

Giorgione: *Tempest*, 82 × 73cm (and detail, opposite), 1506–8

was not idyllic, but represented total freedom from the values he supposedly rejected. The *Mythological Scene* shows how bleak this vision could be, a treeless and marshy landscape mirroring the human tragedy taking place in front of it.

The sentimental and conventionally beautiful landscape glimpsed behind Perugino's *Apollo and Marsyas* could hardly be more different. The subject is from Ovid, but, in keeping with the spirit of fifteenth-century Umbrian art, the earlier moment of the competition is portrayed and not the horrific conclusion. Indeed so restful is Perugino's picture that it is hard to imagine that any nastiness is about to happen; instead the pipe-playing Marsyas, seated on a rock in idyllic surroundings, incorporates into Ovid's text another literary tradition – that of the pastoral. This tradition goes back to the Greek author, Theocritus, but is most famously epitomized in the *Eclogues* and *Georgics* of Virgil. In the late Middle Ages both Dante and Petrarch had incorporated pastoral elements into their poetry, but it was not until the Renaissance that the fashion became widespread, with such literary works as Politian's *Orfeo* (1480), Sannazaro's *Arcadia* (1504), Tasso's *Aminta* (1593) and Guarini's *Il Pastor Fido* (1590). The Venetian painter, Giorgione, with his innovatory sensuality in the treatment of light and colour, was ideally suited to convey the beautiful suggestiveness of mood appropriate

to this tradition, and many have actually compared his painted world with the literary one of his Venetian contemporary, Sannazaro. Connections with specific texts are, however, hard to find, and this is certainly the case with Giorgione's *Tempest*, one of the most enigmatic works of the Renaissance. Known by this title since the middle of the sixteenth century, it has been suggested that the artist responded to the technical challenge of emulating a lost work by Apelles that portrayed lightning and thunderclouds. In a less prosaic vein, the art critic, Ridolfi, writing in 1648, believed that the painting referred to lines in Lucretius describing the pitiful state of man exposed at birth to the elements. At all events, the powerful and haunting mood of the painting lives on independent of any intended meaning. Giorgione's remarkable ability to capture atmosphere was inherited by his pupil, Titian, who probably executed the very Giorgionesque *Concert Champêtre*. As in the *Tempest*, the pastoral idiom was here applied to a seemingly contemporary scene, but, once again, the real subject of the painting has been the source of much speculation. The work is certainly an idyll, and given greater sensual embodiment through the imposing fleshiness of the nudes and the seductive suggestion of actual music.

Works like the *Tempest* and the *Concert Champêtre* belong

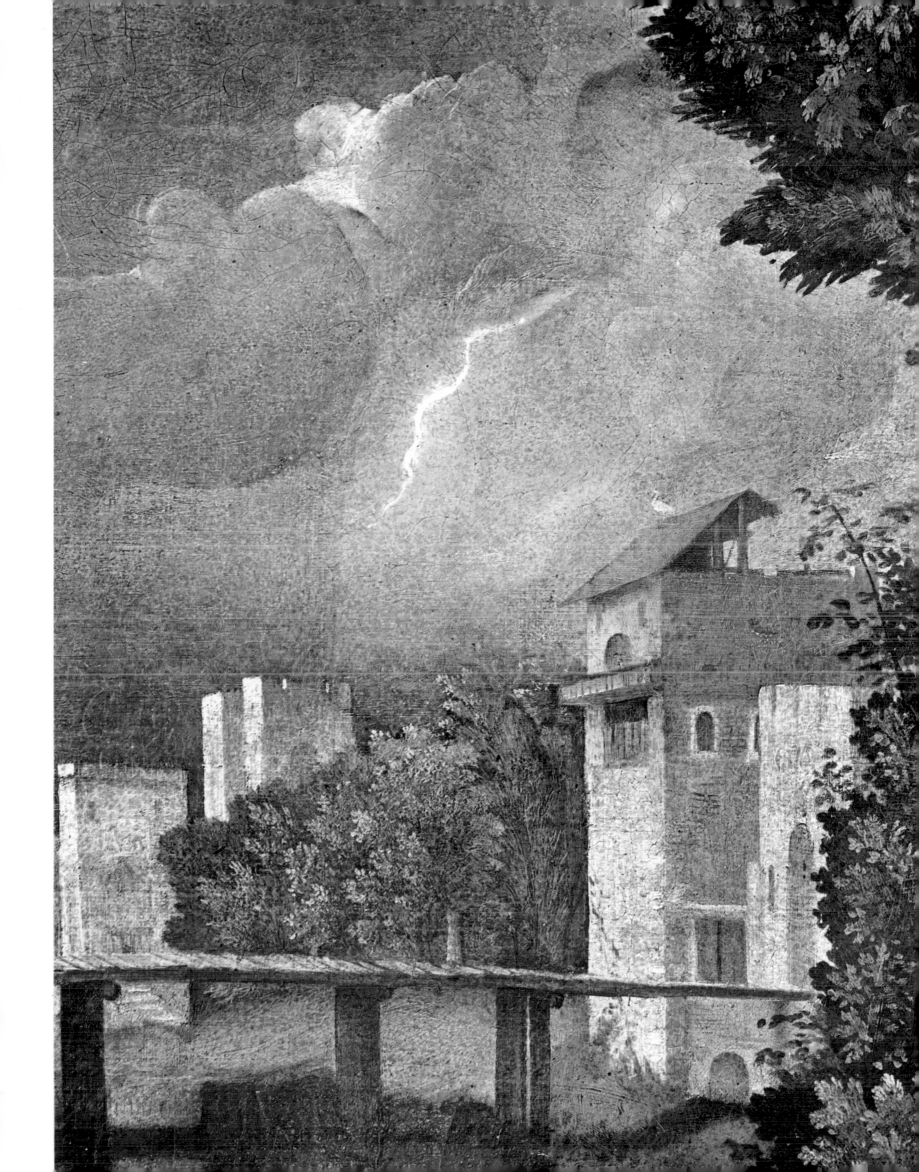

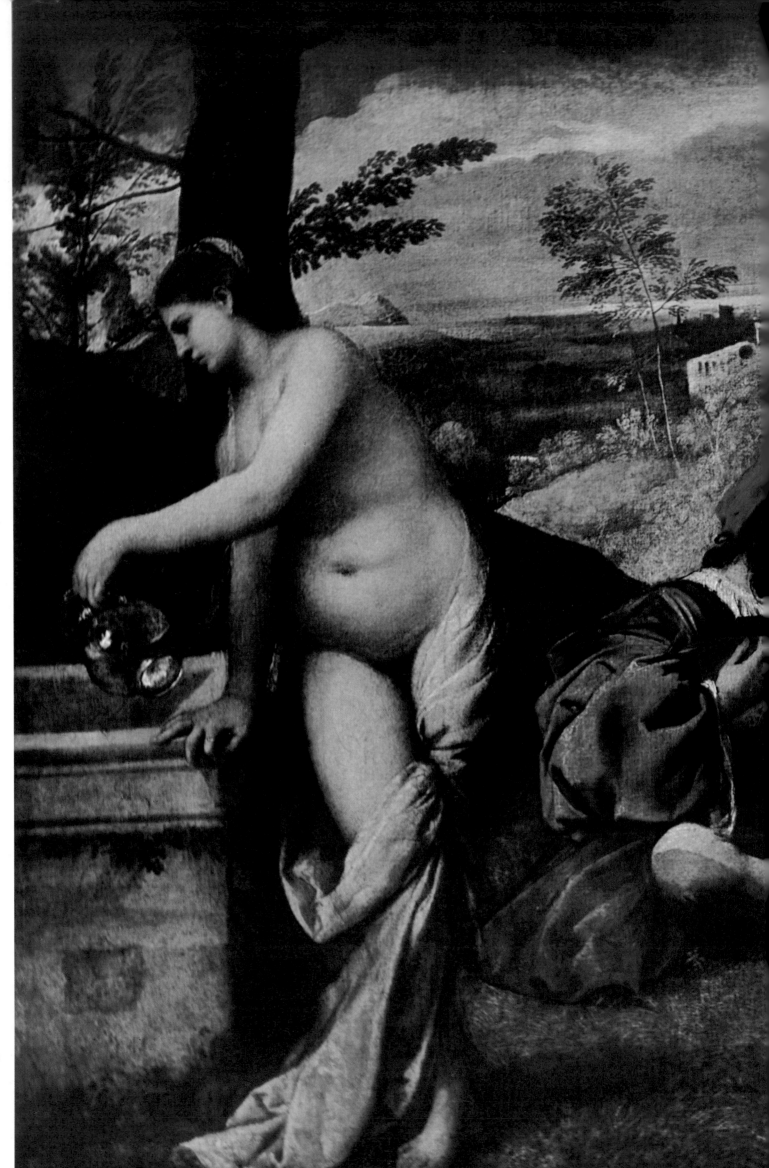

Titian: *Concert Champêtre,* 110 × 138cm. 1510–11

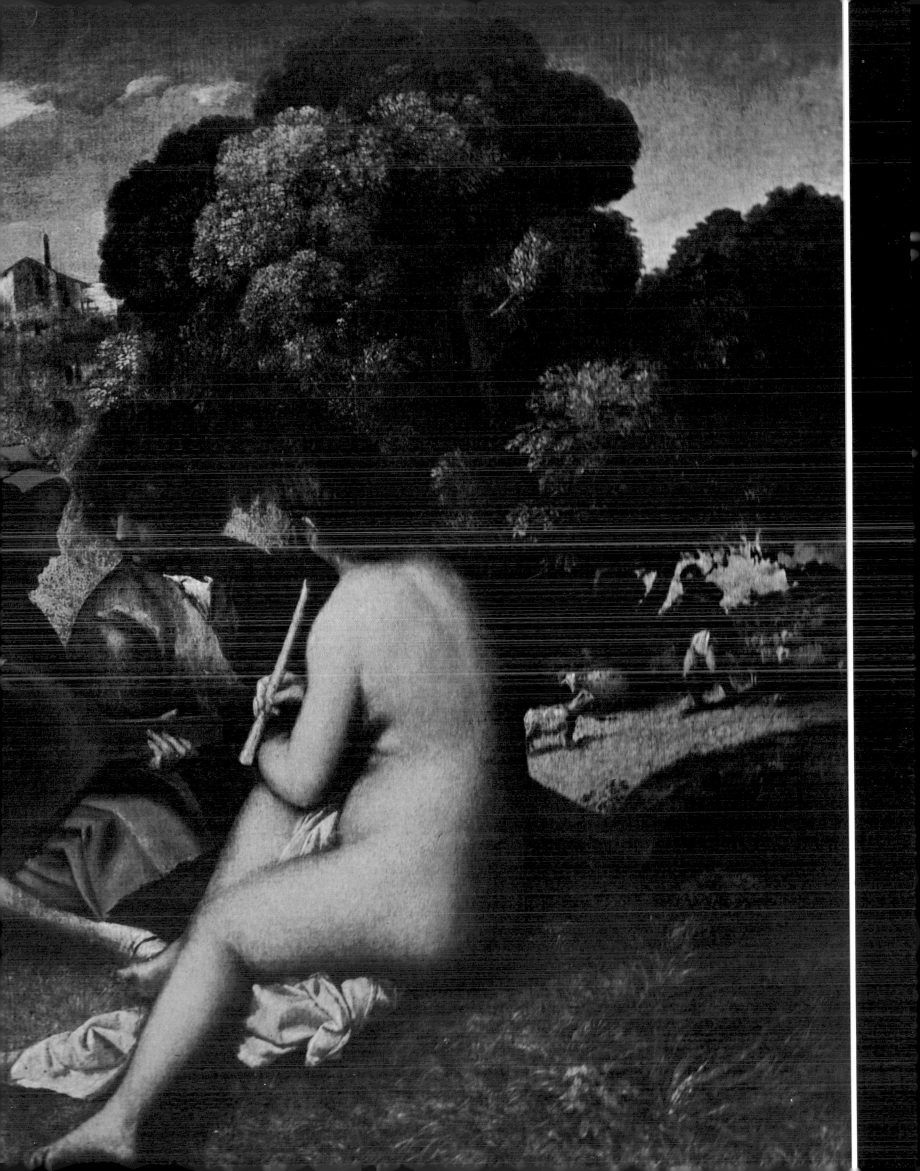

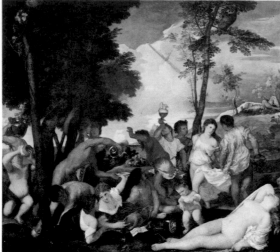

Left **Titian:** *The Garden of Venus*, 172 × 176cm, 1518–19
Below left **Titian:** *Bacchanal of the Andrians*, 175 × 193cm, 1523–5

In February 1518, Alfonso d'Este had the covered passage-way, which led from the castle at Ferarra to the palace across the square, completely decorated. One of the rooms in this so-called *Via Coperta*, Alfonso's *studiolo*, was subsequently furnished with five canvases, one by Bellini, three by Titian and one by Dosso Dossi, the court painter. It must have been Alfonso's intention to rival the Mantua *studiolo* of his sister, Isabella d'Este (see the panels for Correggio's *Danaë* and *Ganymede*), but his own cultural tastes were rather different and closer to those of his nephew, Federigo Gonzaga. Even if a humanist adviser was brought in for some of the finer details of the iconography, a letter from Titian to Alfonso – in which the artist, praising the themes he had to paint as 'so beautiful and ingenious', affirmed his belief that 'the greatness of the ancient painters was in great part and above all aided by those great princes who ordered them' – indicates that it was the patron himself who was responsible for the choice of subjects. Unlike Isabella's *studiolo*, there was no allegorical message in the decoration and the only consistent feature was the sense of playful revelry. The spirit was set by Bellini's *Feast of the Gods*, an earlier commission of 1514 which was later repainted by Titian, to fit in with the rest of the room. Bellini depicted the Gods in a very satirical vein, with such humorous (and erotic) details as Neptune placing his right hand between Cybele's legs, and Priapus, the god renowned for the size of his penis, trying to remove the skirt of the sleeping Lotis. Bellini's sense of humour was shared by Titian, who showed, in *The Garden of Venus*, mischievous cupids playing in Venus' garden, and in the *Bacchanal*, a child urinating, having drunk too much wine. The eroticism intensified, however, the tentative seductive gestures in the Bellini painting, giving way to the rapturous fulfilment of the foreground nude in the *Bacchanal*. On the extinction of the d'Este family in 1598, the paintings in the *studiolo* were brought by Cardinal Aldobrandini to his palace in Rome. In 1637, *The Garden of Venus* and the *Bacchanal of the Andrians* were presented as a gift to Philip IV of Spain.

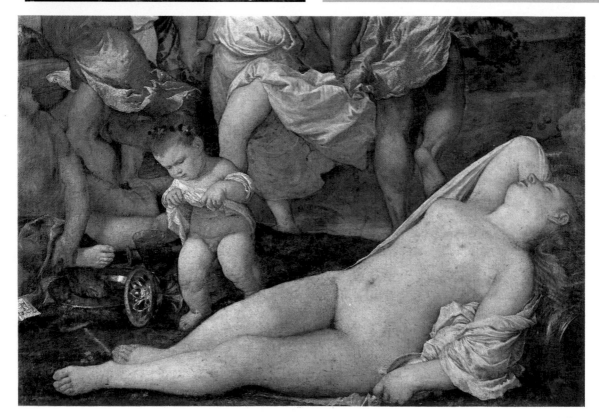

Titian: *Bacchanal of the Andrians* (detail)

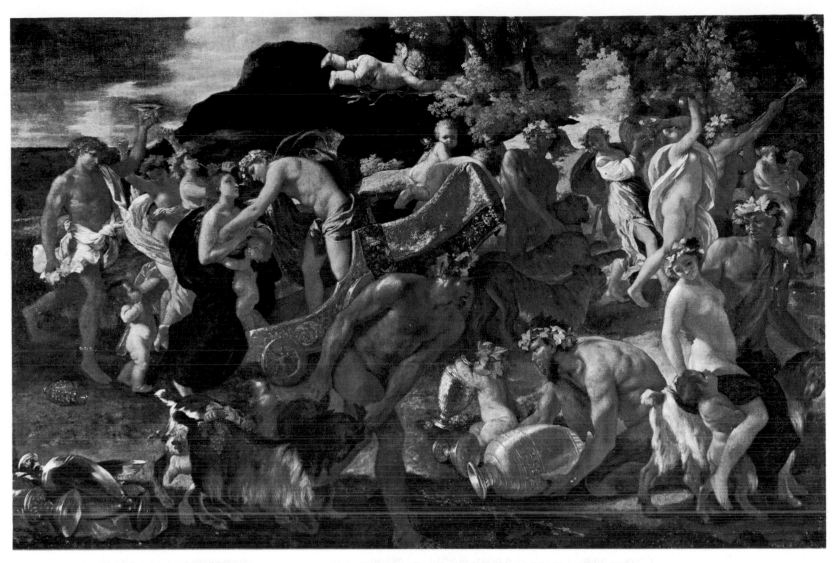

Poussin: *Bacchanal*, 122 × 169cm, c.1630

to an indeterminate category of painting, being neither pure landscapes nor obviously narrative scenes. Many classically inspired paintings that go under the title of *Bacchanal* or *Nymphs and Satyrs* should perhaps be best included in this catory. These are works in other words whose principal aim was the total involvement of the senses, an aim is appropriate to the, at times, orgiastic delirium that overpowered mortal minds under the influence of both Bacchus and Pan. The only specific event in Titian's series of canvases painted for the *studiolo* of Alfonso II, is in *Bacchus and Ariadne*, which depicts the moment when Bacchus runs with his wild procession of followers to meet Ariadne; this meeting has, however, less the interest of narrative than of a striking image of sudden and sensual possession. The ensuing state of mind is portrayed in the other two canvases of the series, *The Garden of Venus* and *Bacchanal of the Andrians*. The two paintings are, in fact, related to specific classical texts, but these (Philostratus' *Imagines*) are no more than word pictures, evocations of purely sensual scenes that the author thought might interest a painter. Their elusive quality certainly offered a considerable challenge: 'Do you catch something of the fragrance hanging over the garden, or are your senses dull? But listen carefully; for along with my description the fragrance of the apples will also come to you.' This is part of a description that inspired the *Garden of Venus*, and the idea that words can convey smell can be paralleled by the way in which Titian's art seems intended to combine a variety of sensual experiences, that of sight being only an introductory one. This enveloping sensual quality is very evident in the scene of the *Bacchanal*, where Titian shows the effect of an unending stream of wine, lulling consciousness to a dream-like state of intense rapture. Philostratus' text demanded a harmonious inter-relationship between figures and landscapes, which Titian responded to, but in his later paintings his treatment of landscape became increasingly summary.

Titian: *Nymph and Shepherd*, 149·6 × 187cm, 1570–5

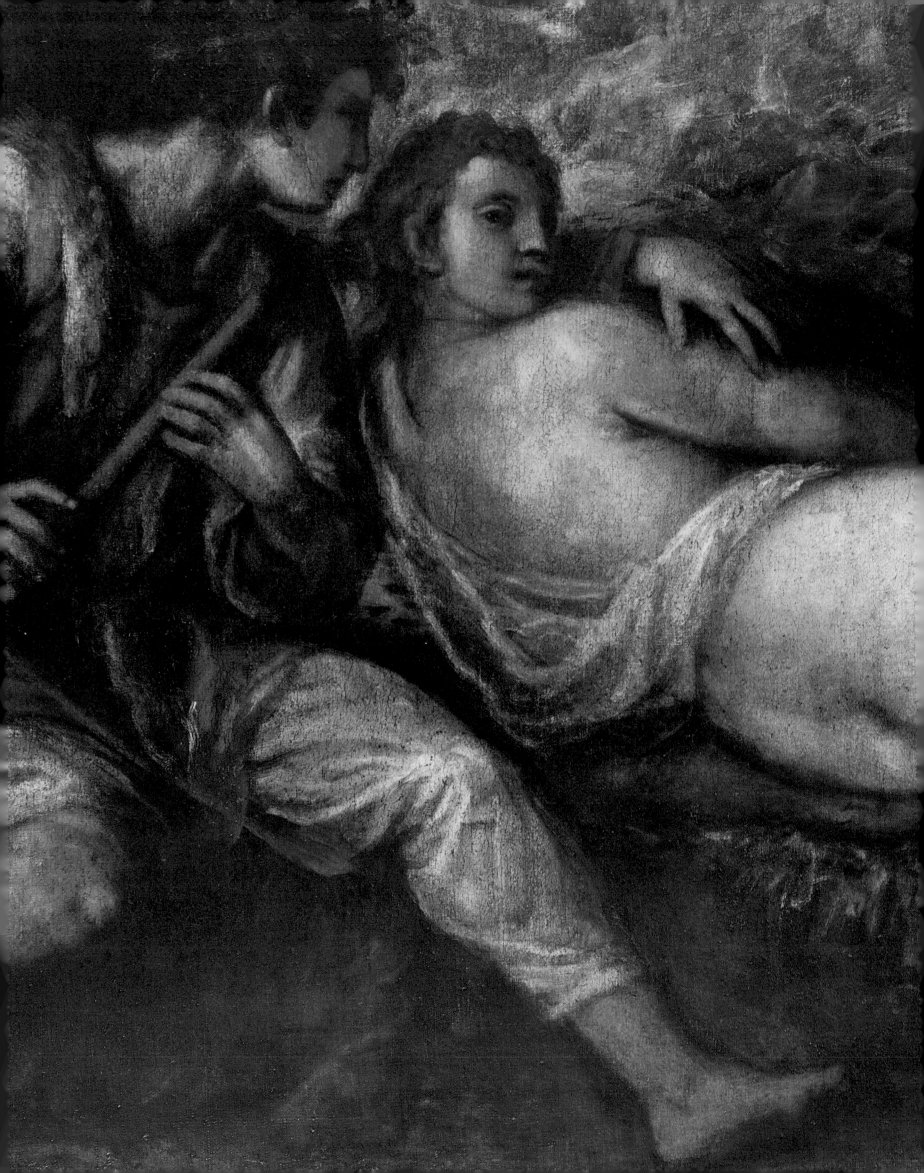

OPPOSITE **Titian**: *Nymph and Shepherd* (detail)

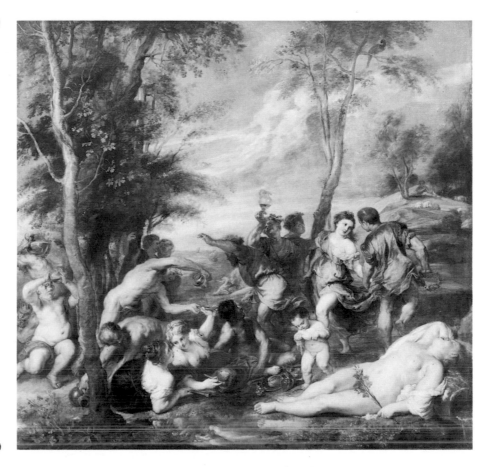

Rubens: *Bacchanal*, 200 × 215 cm, 1630

Eventually the role of landscape as an emotive force was usurped by the powerful freedom of his technique. The *Nymph and Shepherd*, his last known painting, contains all his earlier vividness of mood, but now made more frighteningly dramatic; a colourless, almost monochromatic work, the idyllic charms of nature hardly register against the pulsating forces of human passion.

The strength of Titian's impact on seventeenth-century painting can be gauged by his appeal to such totally opposed artists as Poussin and Rubens. Sandrart wrote that this incongruous pair accompanied him on a visit to see the Ferarra 'studiolo' paintings when they hung in the Aldobrandini Collection in Rome. The *Bacchanal of the Andrians* caused the greatest sensation among the painters of the time. The foreground nude in the picture was universally copied, even by Poussin. Bacchanals were not commonly painted in Titian's time, and they were rarer subjects in the years following the Counter-Reformation. Lack of contemporary prototype might have made Poussin turn his thoughts to Titian when he embarked on a series of bacchanals in the 1630s, such as *Bacchanal* and *Dance in Honour of Priapus*. Although at this early stage in Poussin's career, his art could show a considerable degree of sensuality, the spirit was radically different to Titian's and more an archeologically inspired reconstruction of the Dionysiac rites depicted on classical reliefs. The popular conception of what a bacchanal should look like owes virtually everything to Rubens. Rubens' copy of Titian's *Bacchanal of the Andrians*, interestingly shows how he too approached the subject in a very different mood to Titian. Instead of the intensely vivid study of irrational mental possession, Rubens gives the impression that wine-drinking is a healthy sport; accordingly, the naked woman in the foreground, who in Titian's picture

conveyed delirious rapture, here opens her mouth in an expression of near-bestial satiation. At least one of Titian's beautiful youths has been transformed into a middle-aged man, and likewise in Rubens' other bacchanals (as in that of his follower, Van Dyck), the artist preferred the image of Bacchus as a rather unglamorous old man, collapsing under the influence of drink. Rubens' sense of humour was more open and less malicious than that of Titian, but was also less subtle. His other tendency was to exaggerate, something latent in *Bacchanal*, and which at other times, as in *Diana and the Nymphs*, goes blatantly over the boundaries of tasteful restraint to create a *tour de force* of impassioned

Poussin: *Dance in Honour of Priapus* (detail), 1638–40

LEFT **Jordaens**: *Allegory of Fecundity*, 180 × 241cm

RIGHT **Van Dyck**: *Drunken Silenus*, 107 × 91·5cm, c.1620

BELOW **Rubens**: *Diana and her Nymphs*, 123 × 314cm, 1635–40

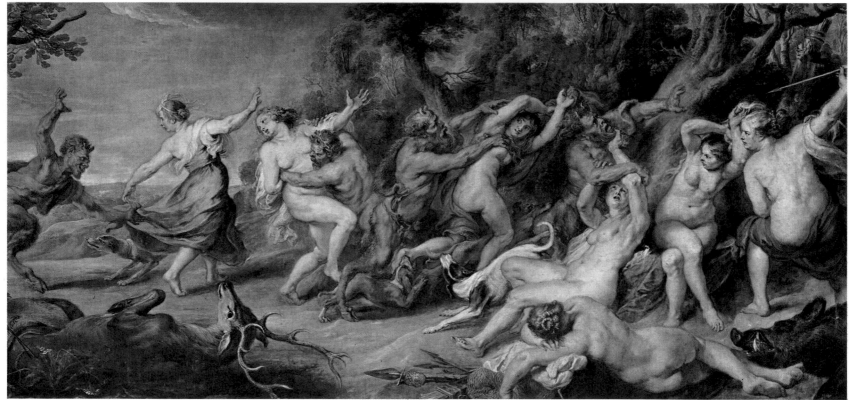

energy. Rubens' ideal of healthiness and vitality was encapsulated in the freshness of his landscape backgrounds, and, similarly, the nudes that populate these landscapes have all the attractiveness of natural abundance. The qualities that one admires in women such as those in *The Three Graces* are like those of the cornucopia of agricultural wonders that surround them; in the hands of a less great artist, like Rubens' major follower, Jacob Jordaens, as in his *Atalanta and Meleager* and *Allegory of Fecundity*, the same images of fertility express a purely material approach to nature, which can quite easily turn a mythological scene into no more than a succulent still-life.

Throughout the Renaissance the role of landscape, however emotive, had been largely relegated to the background of a mythological painting, but in the seventeenth century it came more properly into its own, often reducing the foreground scene to irrelevance, as, for instance, in the mythological landscapes of Saraceni. It was Claude, however, who most persuasively evoked the lost paradise of Arcadia and of the Golden Age, and who gave these idyllic visions greater potency by showing how the works of classical authors could be actually related to the Roman Campagna. The setting of the *Landscape with the Nymph Egeria*, for instance, is clearly that of Lake Nemi, a location both appro-

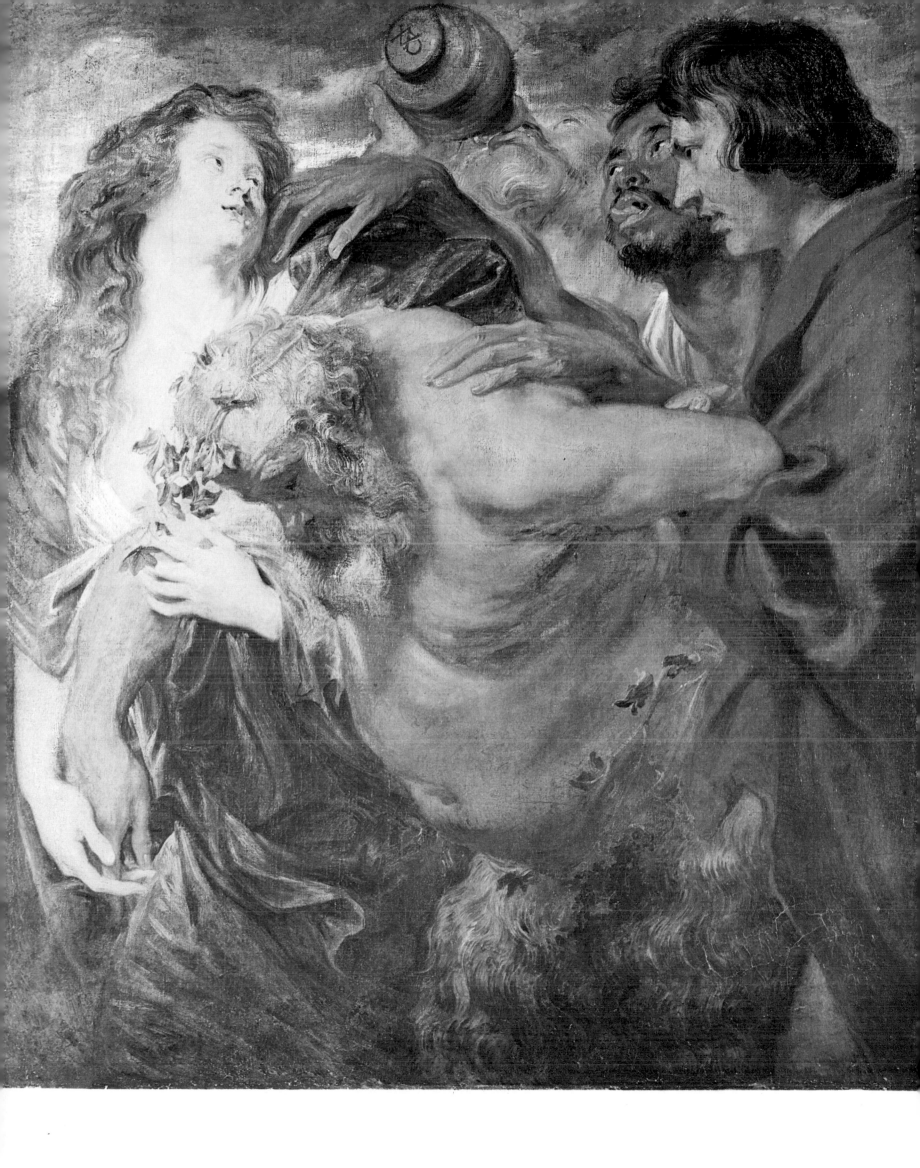

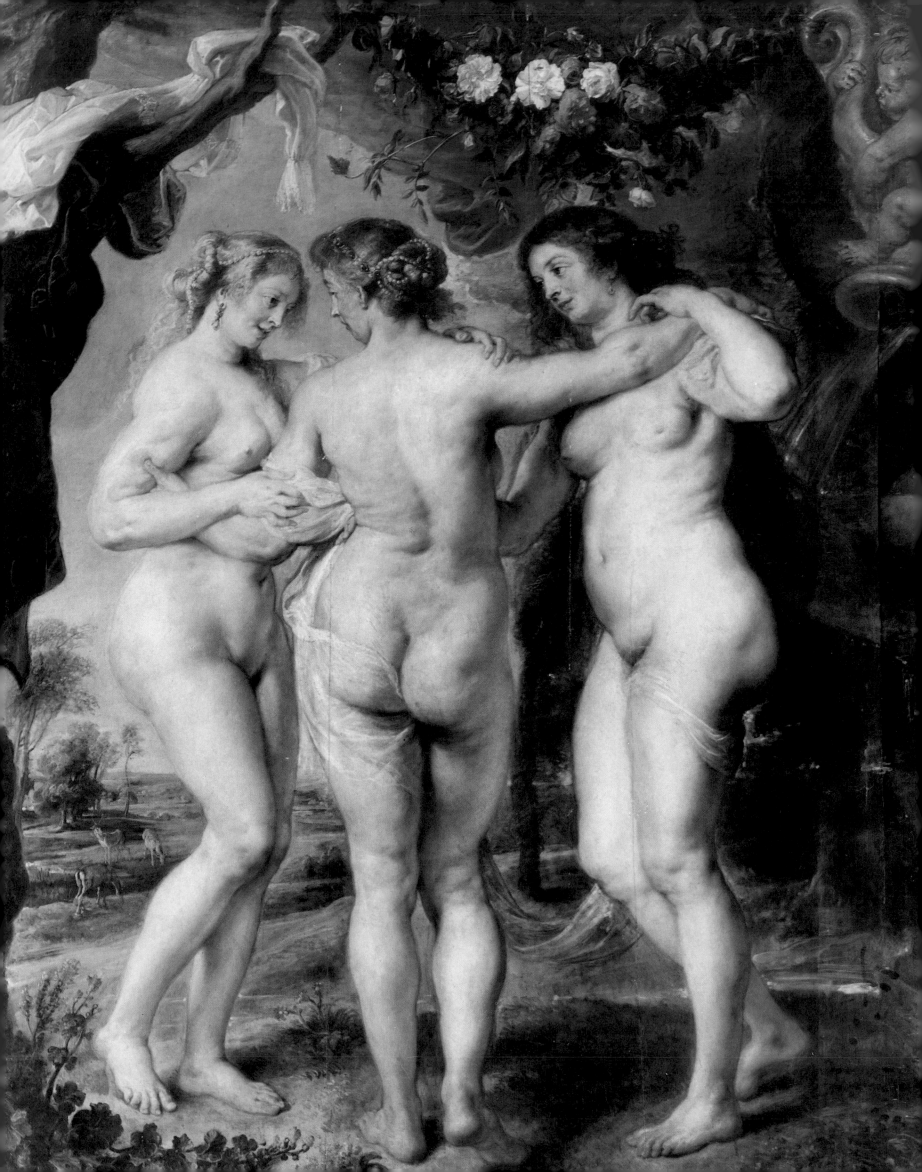

priate to the patron who commissioned the work, Prince Colonna, owner of the castle in the background, and also to its ostensible subject, who in antiquity was believed to have haunted the lake. The realistic basis for many of Claude's paintings is, however, only a starting point for an experience of a very different kind; as one's eye is gradually hypnotized by the intricate subtleties of light, and drawn ever further back into a seemingly infinite recession of water, hills, and trees to a gilded horizon, one realizes that one has become fully immersed in the spirit of a bygone age. Looking at any strikingly beautiful landscape is itself a deeply nostalgic experience, but when combined with an evocation of an imaginary world, a sense of sadness becomes the dominating emotion. Characteristically, it was Poussin who turned this sadness into tragedy with the suggestion that even death has its place in Arcadia. The gentle lyricism of his two representations of 'Et in Arcadia ego' gives way to the melo-

ABOVE **Saraceni**: *Landscape with Ariadne*, 41 × 53cm, c.1608

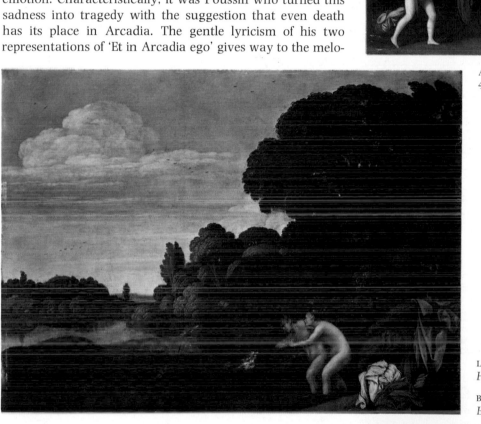

LEFT **Saraceni**: *Landscape with Salmacis and Hermaphroditus*, 41 × 53cm, c.1608

BELOW **Claude**: *Landscape with Nymph Egeria*, 155 × 199cm, 1669

dramatic landscapes of later life, such as *Landscape with Orpheus and Eurydice*. His last mythology of this type goes further still, reducing the human element to insignificance, and incorporating the philosophical doctrine of pantheism. In spirit these paintings represent the opposite extreme to visions of a purely sensual Arcadia, but whether tragic or idyllic, all mythological landscapes, in their subordination of subject-matter to mood, most obviously take one back to what one imagines as the essence of antiquity.

The principal tenet of humanism – that the proper study of mankind is man – indicates one major consideration to be taken into account in any final assessment of mythological painting. However much one is aware of the classical culture on which these works are based, this knowledge greatly loses its value if one fails to recognize the specific requirements of the society for which they were created. The discrepancies between humanistic theory and practice, between literary text and its painted interpretation, come more fully into the open as soon as the question of patronage is raised.

The revival of interest in mythological painting began

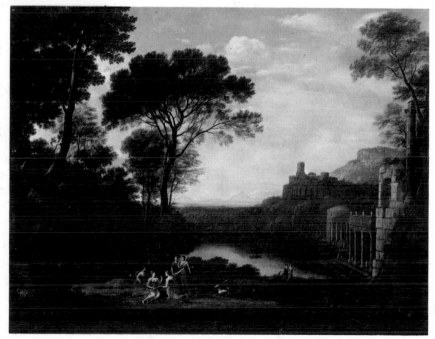

OPPOSITE **Rubens**: *The Three Graces*, 221 × 181cm, 1638–40

essentially in fifteenth-century Florence, a time and a place particularly prone to inspire sentimental historical fantasies. Compared with later centres of patronage, its middle-class government made it reasonably enlightened, although the common idea of the supremely civilized patron conversant with all the latest developments in Neo-Platonic thought must accommodate the blunter outlook of people like Francesco Pugliese, who significantly owned several mythologies by Piero di Cosimo, and who was later banned from the city for publicly calling Lorenzo de' Medici the Younger 'the Magnificent Shit' ('*il magnifico merdo*'). As a rule, mythological painting flourished under the more absurd exigencies of court culture, which turned increasingly to classical legend for moral support. Only in 1530, when the bastard Alessandro de' Medici was made Duke of Tuscany by the Hapsburg Emperor, Charles V, was such a culture created in Florence. Both Alessandro, known especially for his sexual promiscuity, and Cosimo, his successor, inherited none of their predecessors' humanistic interests. Bronzino's *Allegory*, belonging to the period of Cosimo's rule, can be seen as typical of the new spirit of court art, pornography under the guise of extreme refinement. Gone now is even the semblance of

Below **Clouet:** *The Bath of Diana*, 78 × 110cm
Right **Fontainebleau School:** *Diana as a Huntress*, 192 × 133cm, c.1550

The way in which the world of classical legend could be applied to the life style of a court is well illustrated in the case of sixteenth-century France. France had been rather slow to adopt the Renaissance cult of classical antiquity, and it was only with Francis I, in the third decade of the century, that the new developments in Italian art began to be taken seriously. The impetus for this classical revival was Francis' decision in 1528 to rebuild the old castle at Fontainebleau; the new palace became one of the most important showcases of Mannerist art. The extreme preciosity of the environment is exemplified in Francis' love of the Florentine mannerists, some of whom, like Il Rosso, were actually brought to the palace; the king was suitably a later recipient of Bronzino's *Allegory of Love and Time*. In literature the new interest in antiquity was displayed in the writings of a group called *La Pléiade*, in whose poems the classical gods were frequently found wandering in the world of contemporary man. This is also what is happening in Clouet's *Bath of Diana*, where the man on horseback wears the colours of Diane de Poitiers, and might well be her lover, Henry II. Although too old to pose herself, the Diana figure is probably a flattering portrait of her, and in a later version of the painting, in which the horseman has been changed into Henry IV, the foreground figure has the recognizable features of his mistress, Gabrielle D'Estrées. In French art and literature of the sixteenth century, a whole cult grew up around the lithe virgin goddess, Diana; the presence of this huntress was certainly appropriate to the forests of Fontainebleau, but it was only under the supremacy of Diane de Poitiers that the cult could acquire such personal connotations. There is, of course, extreme irony in the worship of virginity when one considers the status of the specific person alluded to, but such discrepancy can also be found among the poets of *La Pléiade*, who revelled in the world of classical learning almost as an excuse to indulge wholeheartedly in the pleasures of sex.

Above **Poussin:** *Landscape with Orpheus and Eurydice*, 120 × 200cm, 1650

Although both Claude and Poussin related classical legend to the surroundings of Rome (in this case the Castello Sant' Angelo can be seen in the background), they had a fundamentally different approach towards landscape. While Claude concentrated on a delicate rendering of the subtleties of light and atmosphere, Poussin was more interested in dramatic impact. The landscape with *Orpheus and Eurydice* is less frightening and, appropriately to the subject, more lyrical than his usual landscapes of this period, but the precise simplicity and monumentality of its forms still creates a mood of austerity and grandeur. Orpheus, seen during the happy yet brief interlude of his marriage to Eurydice, charms the world by his song; already, however, one of Eurydice's handmaidens, right in the centre of the composition, turns around in shock on seeing the snake, which is eventually to kill her mistress; mirroring her shock, a fisherman is distracted from his peaceful occupation, and the dark smoke billowing from the prominent castle furthers the sense of incipient tragedy.

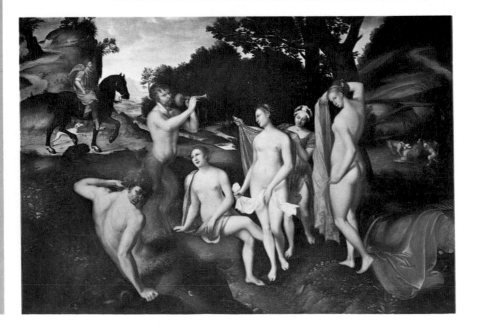

OPPOSITE **Fontainebleau School:** *Diana as a Huntress*

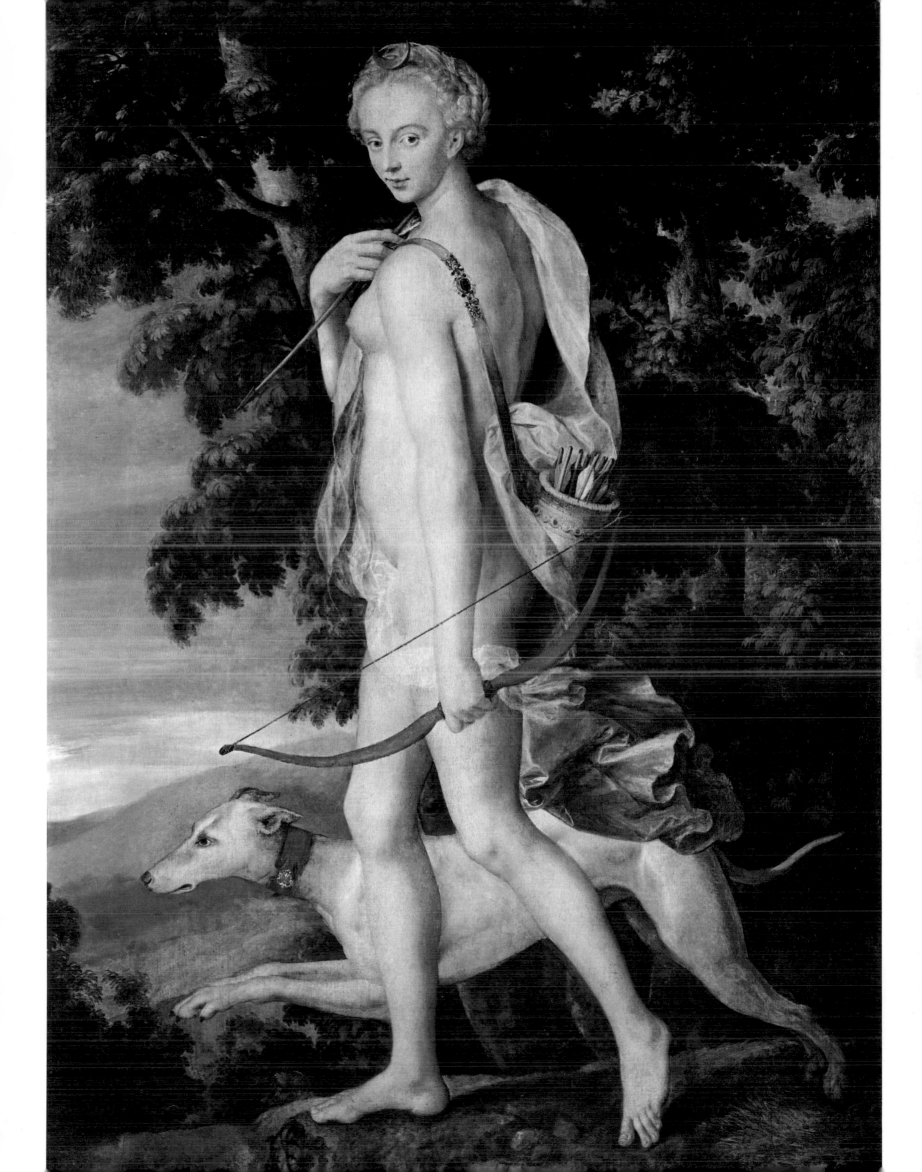

seriousness evident in Botticelli's earlier mythologies, and instead the eroticism is combined with blatant humour, an element in the work which art historians, in their search for some erudite meaning, have gradually overlooked. The subject of Bronzino's painting is probably Venus disarming Cupid, but both, although distracted by a flower-throwing putto, seem to be greatly enjoying themselves, much to the frustration of the melodramatically despairing figure above Cupid's prominent bottom, and to the disapproval of the kill-joy figure of Time in the background; added to this are the usual Mannerist tricks, such as the angelic face of a creature who turns out to be a griffin or the mask that looks human.

The most dominant characteristic of Cosimo's artistic patronage was, however, the commissioning not of works of this sort, but rather of works that strengthened the dynastic image of the Medici. While Cosimo settled for more straightforward propaganda, such as portraits and equestrian statues, other courts made extremely sophisticated use of mythology as self-advertisement. Isabella d'Este is a striking example of this more intellectual type of patron. Her employ-

ment of the humanist adviser, Paride da Ceresara, for the choice of subjects for her *studiolo* in the Ducal Palace at Mantua, has already been commented on, but not the ulterior motives behind all the display of erudition. The *studiolo*, a very popular Renaissance concept, was essentially a cultural status symbol, a private equivalent of those art centres of today that have been endowed by large business concerns. The first artist to be commissioned for Isabella's *studiolo* was Mantegna, whose *Minerva Expelling the Vices* and *Mars and Venus* depict, with the most complex symbolical devices, the superiority of reason over sensuality. At this early stage of the decoration, there seems to have been no specific allegorical programme for the whole room, but gradually over the fifteen years it took to bring all the work to completion, this situation changed. The virtuous message of the Mantegna paintings, expressed with much subtlety, was more crudely expounded in Perugino's painting devised by Paride da Ceresara which in spite of the multitude of specific classical figures, took the form of a straightforward battle between the virtues and the vices, an almost medieval conception reflecting Isabella's love of French chivalric literature. That

Titian: *Venus and Cupid with an Organist*, 146 × 217cm, 1545–8

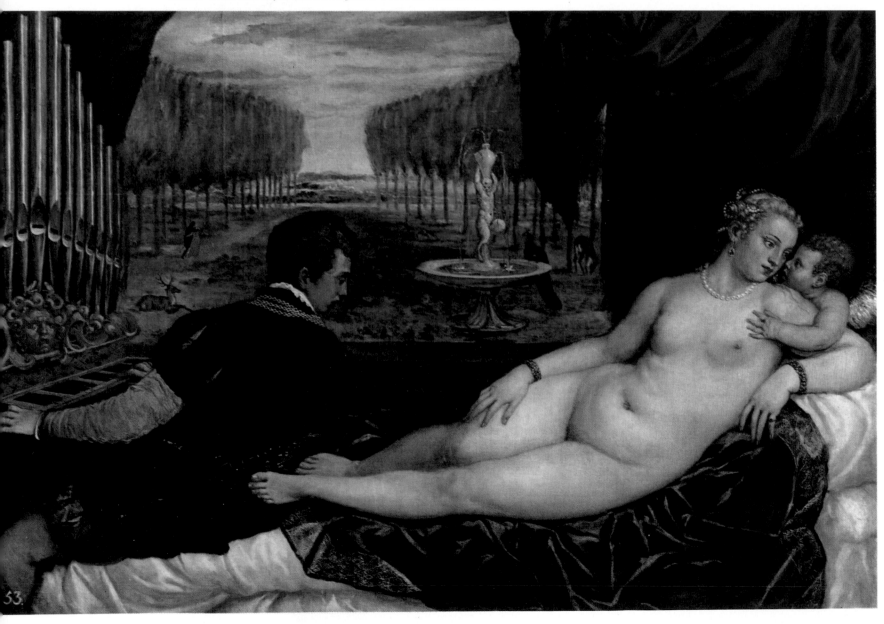

OPPOSITE **Bronzino:** *Allegory of Love and Time*, 151 × 116cm (and detail, pages 54–5), c.1540

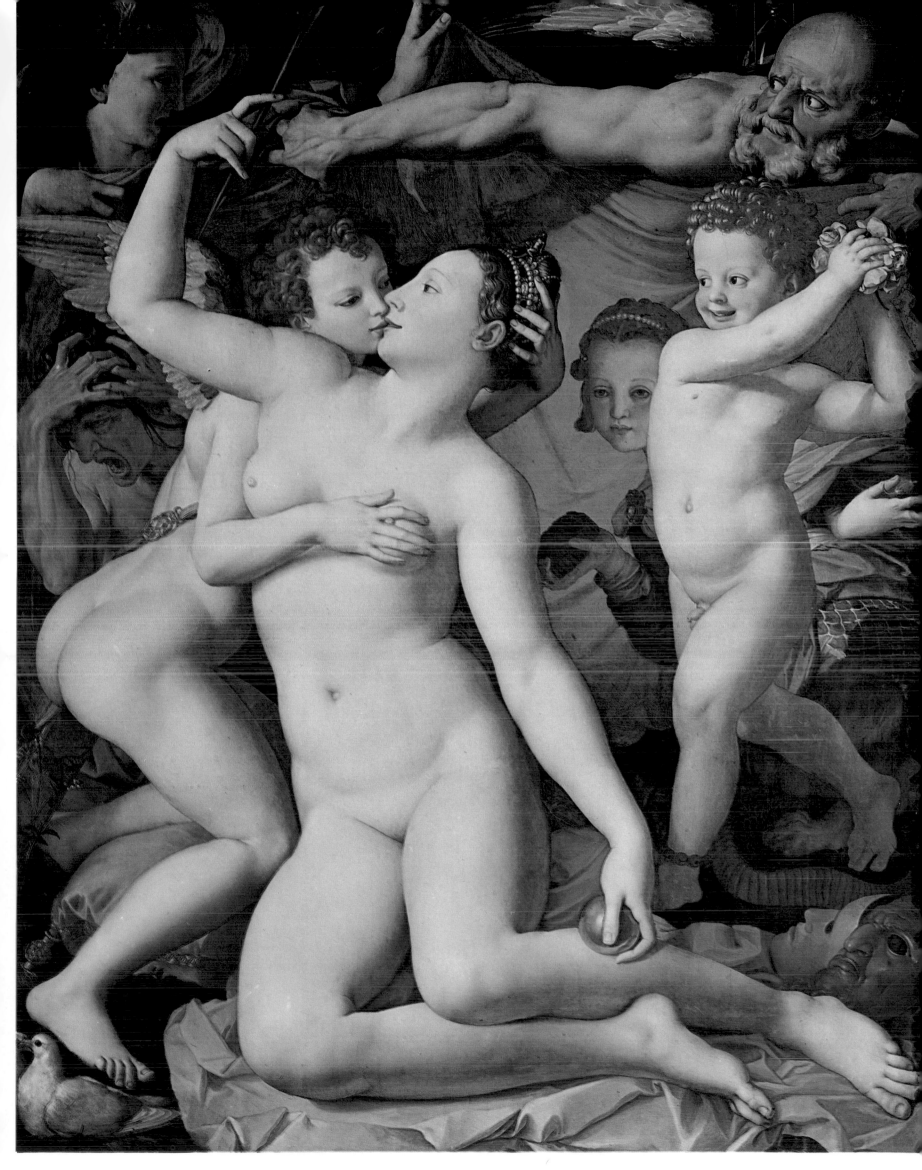

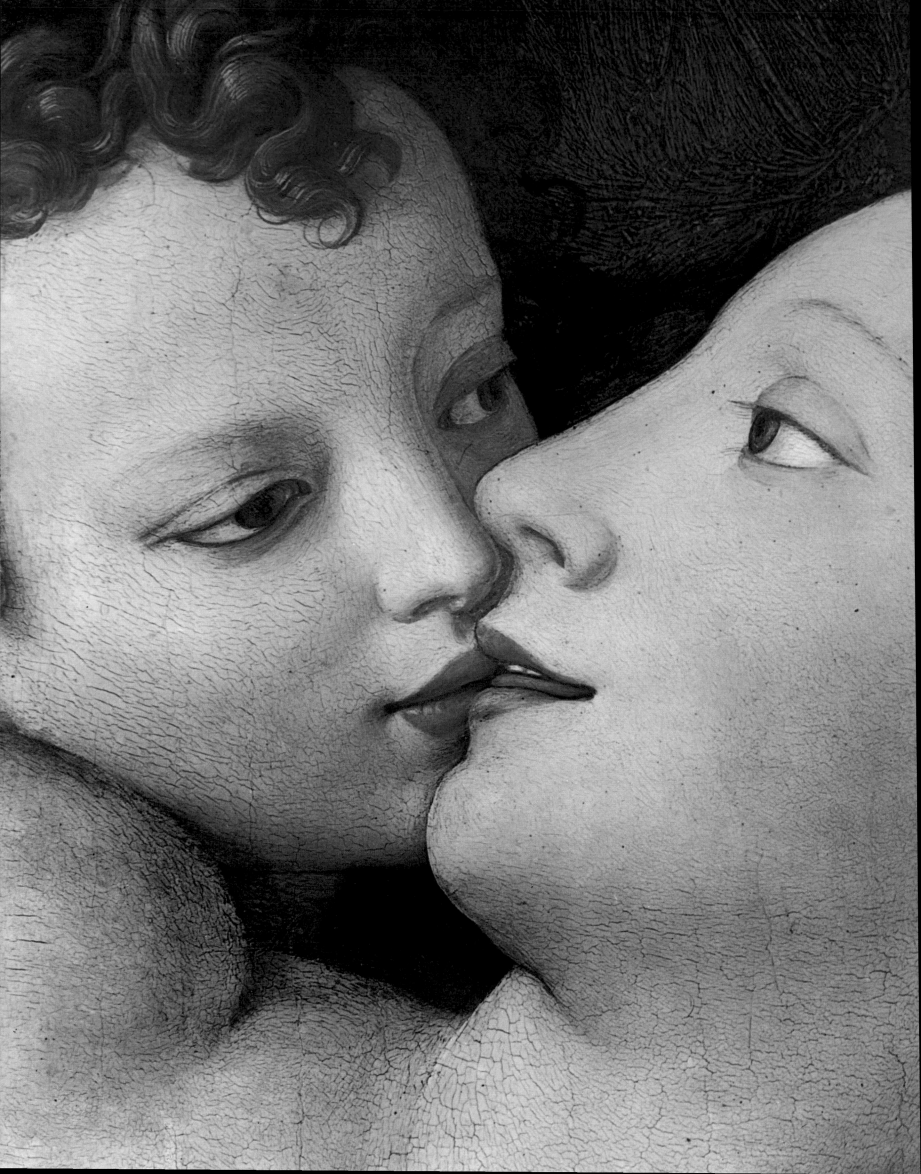

she identified herself in the role of a moral campaigner is made clear in the culminating allegory of the cycle, Lorenzo Costa's *Coronation of a Lady*, the lady in question being most probably a portrait of Isabella, who is shown rewarded for

her admirably virtuous life. Isabella d'Este is generally regarded as one of the most remarkable women of the Italian Renaissance, but this determined bluestocking's advocacy of chastity must be seen in the light of her husband's constant absences from Mantua. The ideas expressed in Isabella's *studiolo* become particularly absurd when one considers the activities of her son, Federigo Gonzaga. Even before Federigo became fifth Marquis of Mantua in 1519, he was quite openly living with his mistress, Isabella Boschetti, who was to exert an increasing influence on him during the 1520s. Around 1525, Federigo had transformed for her a modest portion of his stables, in the outlying Isola del Te, into a villa – a building which, like his mother's *studiolo*, was to turn into his own personal manifesto. This manifesto is largely summarized in the inscription appearing all around the four walls of the *Sala di Psiche* (Hall of Psyche): 'Federigo II Gonzaga . . . ordered this place built for honest leisure after work to restore strength in quiet.' Just in case one has any doubts as to what form this leisure took, one only has to look up to the emblem, appearing all over the ceiling, in which a lizard is accompanied by the words 'What does not affect him, tortures me', an allusion to the lizard's apparent ability to withstand love. The man chosen for both the architecture of the villa and its painted decoration was appropriately Giulio Romano, a pupil of Raphael whose series of 'sixteen erotic postures showing the various manners, attitudes, and postures in which lewd men have intercourse with lewd women' had caused their engraver, Marcantonio, to be put into prison, and had inspired some equally notorious sonnets by Aretino. Even before entering the building,

Left **Correggio**: *Ganymede*, 163·5 × 70·5cm, c.1534
Right **Correggio**: *Danaë*, 161 × 193cm, and detail page 58, c.1534

A good illustration of the differing tastes of Isabella d'Este and her son, Federigo II Gonzaga, is shown by their respective commissions to the Parma artist, Correggio. When Isabella moved her *studiolo* in 1522 from the castle of Mantua to the palace proper, there was space for two additional paintings; at a later date, generally considered around 1530, these gaps were filled by two works by Correggio, both of which (allegories of vice and virtue), consolidated the anaemic, moralizing theme of the *studiolo*. For Federigo, however, Correggio produced four of the most notoriously erotic paintings in the history of art. These four paintings, representing the loves of Jupiter, *Leda and the Swan*, *Io*, *Danaë* and *Ganymede*, were probably hung in the Palazzo del Te, in a room which had frescoes from Ovid on the ceiling. The paintings were given to either Charles V or Philip II and remained in Spain until the end of the century, when they were acquired, possibly in exchange for Titian's *Venus and Cupid with an Organist*, by Rudolph II. A later owner, the Duc d'Orléans, was so disturbed by the eroticism of the *Leda* that he had the face of the heroine removed, which was subsequently repainted by a nineteenth-century German painter. A similar fate befell a copy of the *Io* in the same collection. The pornographic nature of this last work was so established in the eighteenth century that a version, half covered by a curtain, was depicted by Hogarth in the background of one of the canvases from the *Marriage à la Mode* series, a study in contemporary corruption.

architectural jokes, such as the famous fallen triglyph, put the visitor into a lighthearted frame of mind. Inside, two spectacularly entertaining rooms await him. In one, the *Sala dei Giganti* (Hall of Giants) remarkable *trompe-l'oeil* creates the impression that the whole structure is collapsing; in the other, the *Sala di Psiche*, there is a breath-taking proliferation of sexual activity, with such scenes as Jupiter and Olympus recreating one of the famous postures, or Adonis caught copulating with Venus, and running away without his pants. The building was not, however, a complete joke. What had initially been intended as a modest villa, a convenient meeting place for Federigo and his mistress, was to become an imposing palace clearly designed to impress, and, in this case, one person in particular – Charles V.

In a famous passage in Virgil's Fourth Eclogue, the poet heralds the return of a Golden Age, at the head of which will be the virgin, Astraea, the last of the immortals to leave the earth when it was destroyed by human greed and war. What precisely Virgil had in mind is not clear, but his prophetic lines impressed themselves on the European imagination for many centuries, and became directly associated with the idea of empire. At no stage in European history did this prophecy seem closer to fulfilment than during the reign of Charles V, whose conception of a universal empire was sanctioned by one of a universal church. When these dreams were shattered by his sudden retirement in 1556 to the Jeronymite Monastery of San Yuste, in northern Spain, the symbol of Astraea did not entirely lose its validity, but was applied to the slightly less glamorous courts of late sixteenth-century France and England. In the case of Elizabeth I, the idea of Astraea as symbol of Justice and universal Peace could be combined with that of Virginity, for she was indeed an unmarried Queen, an important factor in her European political role. The involved lengths to which the quaint language of mythology was made to express political realities now constitutes the most inconceivable and absurd aspect

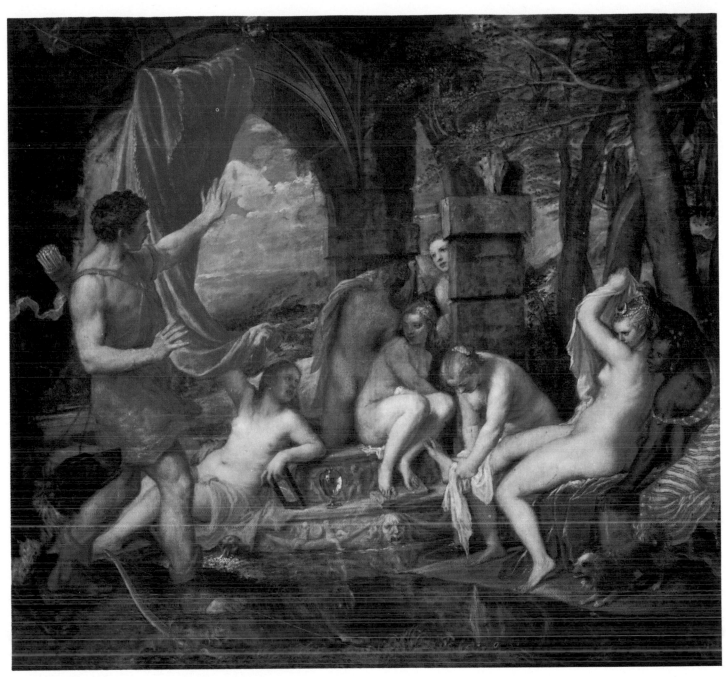

Titian: *Diana and Actaeon*, 188 × 206cm, 1556–9

of much allegorical art of the past. It is typical of the very humane character of Charles V that, although his role in bringing back Astraea to earth was emphasized in contemporary literature – as, for instance, in the *Orlando Furioso* of Ariosto, whom the Emperor met on his 1532 visit to Mantua – the actual paintings he commissioned were remarkably straightforward, like those of his adored Titian, whose bluntness and spontaneity was obviously close to Charles's heart. When he commissioned Titian to paint an equestrian portrait, Aretino uncharacteristically suggested that his friend should include a variety of allegorical figures, but his advice was not heeded, and instead the artist produced a strikingly direct portrait in which a sense of grandeur is allied to his habitual one of intimacy.

The humane qualities of Charles V were not inherited by his son, Philip II, and while the idea of a universal church was expressed by the father in terms of a benevolent Erasmianism, in the son this was replaced by a fervently austere and orthodox Catholicism, which certainly could not lean for support on pagan myths. Only, in fact, with Rubens, working for the archdukes at the Court of Brussels in the early seventeenth century, was painted allegory used in a grandiose way to further the Hapsburg cause. In the meantime, both with Philip II and his nephew, Rudolph II, mythology ironically adopted its more usual guise as an erotic stimulus.

One of the great ironies in the history of mythological painting is that so many of its greatest and most blatantly sensual examples should end up in the fanatically religious environment of Spain. Some of the first of these works were a series of Ovidian scenes by Correggio depicting the seductions of Jupiter, including the *Io* and *Danaë* which have already been noted for their sexual explicitness. It comes as no surprise that the original instigator of these canvases was none other than Federigo Gonzaga, and that they were probably hung in the Palazzo del Te; at some stage Federigo gave them as a gift to either Charles V or, perhaps more likely, the then Prince Philip, who would have certainly been the more appreciative recipient. Like his father, Philip became an enthusiastic admirer of Titian, but instead of limiting his patronage to portraiture, he was responsible for commissioning the artist's most extensive series of mythologies, which included *Danaë* and *Diana Actaeon*. In his correspondence with Philip, Titian referred to these as 'poesie', a description that has frequently been interpreted as indication of the pure poetic spirit of Titian's late works, but that more

Spranger: *Pallas Proecting the Arts and Sciences,*
163 × 117cm, 1592

likely was a euphemism for the usual Ovidian erotica. After
Philip's final return to Spain in 1599, his energies were
largely channelled into building and embellishing the monas-
tery of the Escorial; in keeping with his growing religious
obsession, he demanded a greater austerity in architecture
and music, but in painting he remained as morally am-
bivalent as ever, avidly collecting, for instance, the bizarre
paintings of Hieronymus Bosch, including that pornographic
masterpiece, *The Garden of Earthly Delights.* The cold, aloof
and ascetic side to Philip's personality seems to have been
compensated by a love of the sensational, manifesting itself
in the monumental scale of the Escorial, or in the strength
of emotions aroused by the paintings in his collection. The
spirit of Titian's late mythologies — energetic, original, and
uncomprisingly brutal and erotic — ideally suited him.

Rudolph II, from the eastern branch of the Hapsburgs,
acquired a reputation as legendary as that of his uncle,
whom he detested. Lacking Philip's orthodox Catholic con-
victions, Rudolph's court at Prague was completely open to
some of the more enlightened thinkers of the time, including
Giordano Bruno, who was later burnt for heresy. As he
grew older, Rudolph indulged his mania for collecting
esoterica and the occult, and like the later Ludwig II of
Bavaria became so immersed in his fantasy world that he
was eventually deposed, considered mad even by the closest
members of his family. Unlike Philip II, his taste in art was
more for the precious and the small-scale *objet d'art*, and he
would perhaps have been antipathetic to many of Titian's
late mythologies. Correggio, on the other hand, had exactly
the right note of refinement, and when Philip II died
Rudolph II managed to procure two of the artist's Ovidian

scenes, *Io* and *Ganymede.* Like so many of the great collectors
of mythologies, there is clear proof that his interest in class-
ical subject matter was subordinate to a love of a work's
sexual content. One of his favourite artists was understand-
ably the Mannerist sculptor, Giovanni da Bologna, in whose
work eroticism is tantalizingly contained within a framework

Below **Rubens:** *The Birth of Venus,* 26·5 × 28·3cm,
1636–8

In 1536, the year after Rubens designed the pageant
for the Triumphant Entry of the Cardinal-Infante Don
Ferdinando into Antwerp, Don Ferdinando secured for
him perhaps the largest mythological commission of all
time. These sixty canvases, combined with a further
sixty hunting and animal pictures by Snyders, were
intended for Philip IV's hunting lodge near Madrid, the
Torre de la Parada, and were delivered there in 1638,
only a year and a half after being ordered. Although
Rubens did all the designs himself, bad attacks of gout
made him leave the execution of most of the canvases
to his pupils; the majority were destroyed when the
building was sacked during the Spanish War of
Succession in 1715. As a series it was even less
unified than Titian's *poesie* for Philip II, for not all the
scenes were from Ovid. A similarly slapdash approach
seems to have characterized the planned arrangement
of the paintings in their intended environment; in fact,
when they arrived at the lodge, there were great
difficulties in fitting them to the walls, and many
empty spaces were left which had to be filled. Rubens
was paid a relatively small fee for the commission, and
all factors combined hint that Philip was essentially
interested in having a large number of mythologies on
the cheap. Although Rubens' designs displayed all his
customary verve, the compositions were in many cases,
such as *The Fall of Icarus,* exactly copied from illus-
trated editions of the *Metamorphoses.* Rubens
emphasized the very human and humorous side to
classical legend, but his approach was at times a
pedestrian one; in the *Birth of Venus,* for instance, the
goddess seems merely to be coming out of the water
after a refreshing dip.

Poussin: *Apollo-Bacchus*, 98 × 73·5cm, 1626

The intellectual stimulus of Poussin's circle created a new category of painting, neither straightforwardly narrative, nor crudely allegorical, but which most closely fulfilled the axiom of *ut pictura poesis*. The *Apollo-Bacchus*, typical of this new sort of poetical-allegorical work, seems initially to have been an illustration of the myth of Bacchus and Erigone, a myth cursorily referred to in the *Metamorphoses* as one of Arachne's woven illustrations of the way in which the gods cunningly seduced mortal maidens: '(and there is) Bacchus as he deceived Erigone by means of a sham grape'. Instead of merely depicting Bacchus, however, the artist also intended the central figure to be interpreted as Apollo. The God of Wine and the God of Reason would seem to be incompatible, but they were frequently reconciled in Renaissance and Baroque literature; in accordance with the Bacchus-Apollo conception, the Erigone figure can either be interpreted as a bacchante or a muse. This complex painting can be compared with the more famous Louvre *Inspiration of the Poet* of a similar date, for it also seems a commentary on the nature of poetry (which is both seductive, like the wine which overcomes Erigone, and also controlled by the more rational forces as represented by Apollo). The two works could have been a flattering homage to another of · Poussin's friends, the celebrated poet, Marino, who was responsible for bringing the artist to Rome, as well as introducing him, in all probability, to Cassiano del Pozzo.

of frigid and ultra-refined precision, and whose lack of interest in the nominal subjects of sculpture was summarized in his description of a figure group intended for Ottavio Farnese, which 'may be interpreted as the Rape of Helen, or perhaps as that of Proserpine, or of one of the Sabine Women'. Rudolph's interest in Giambologna was entirely one-sided, possessing as he did almost all the artist's statuettes of Venus, and, still unsatiated, asking for 'another more naked female figure of the same size'. Giambologna was unable to come to the Court himself, but he offered, as a replacement, another Flemish artist working in Italy, Bartholomäus Spranger. Spranger's famous *Pallas Protecting the Arts and Sciences* shows that even when Rudolph made use of mythology and propaganda, the seriousness of the message disappears under the sensuality of the treatment. The art of Spranger typifies the spirit of Rudolphine patronage, and its precious and unnatural forms remind one that an obsessive passion for the erotic carries with it the lure of a mysterious initiation.

The artistic environment of the later Hapsburg court in Brussels was completely different and more vital. In 1609, Rubens — whose dynamic art forms a complete antithesis to the languid aestheticism of his compatriots, Giambologna and Spranger — was appointed Court Painter to the Archduke Albert and to the Infanta Isabella. Significantly this was the same year that a twelve-year truce was signed in The Netherlands, following years of war between Catholic and Protestant parties; Albert and Isabella clearly wanted to sustain the new period of peace and prosperity with an intensified patronage of the arts. While they themselves largely concentrated their patronage on religious art, their successor, the Cardinal-Infante Don Fernando, provided Rubens with two of his most extensive secular commissions, the designs for the pageant devised for Don Fernando's Triumphant Entry into Antwerp, and the series of Ovidian scenes for the royal hunting lodge near Madrid, the Torre

de la Parada, (*The Fall of Icarus, Diana and her Nymphs, The Birth of Venus*, and *Saturn*). But Rubens' patrons were to be found well beyond the confines of The Netherlands, and the artist, more successfully perhaps than anyone before him, created a truly international language of mythology. Its success purely on the level of gripping entertainment was shown by the Torre de la Parada series, but its greater importance was primarily as propaganda, whether welcoming Don Fernando into Antwerp with allegories of the city's commercial and artistic renascence, apotheosing such figures as James I of England, Henry IV of France, and Marie de Medici, or even illustrating the horrors of war. Its uniqueness was the strength of its conviction, the way in which absurdly plump naked women could not only seem perfectly at ease in their surroundings but actually lend credence to ideas and personalities. This powerful sense of conviction is best understood in the light of the seriousness and depth of the artist's classical learning, and the committed manner in which he could apply classical values to his own life style. Like his brother, Philip, who became the favourite pupil of the Neo-Stoic philosopher, Junius, Rubens was a determined believer in Stoicism, to the extent of having its most famous axiom, MENS SANA IN CORPORE SANO ('a healthy mind in a healthy body') inscribed in the portal of his house. As a true Stoic, much of Rubens' mythological art expressed his fervent belief in peace. Describing to a friend his large allegorical painting, *The Horrors of War*, he referred to the 'grief-stricken woman clothed in black, with torn veil, robbed of all her jewels and other ornaments' as 'the unfortunate Europe, who for so many years now has suffered plunder, outrage and misery'. Rubens' pleading for peace was not just the reaction of a painter, but also of an actual diplomat, whose various missions to Spain, England and Holland, were to secure that very aim. Sometimes the two spheres of his activity coincided, as when he sent a canvas entitled

OVERLEAF **Rubens:** *The Horrors of War* (copy), 47·6 × 76·2cm, 1537

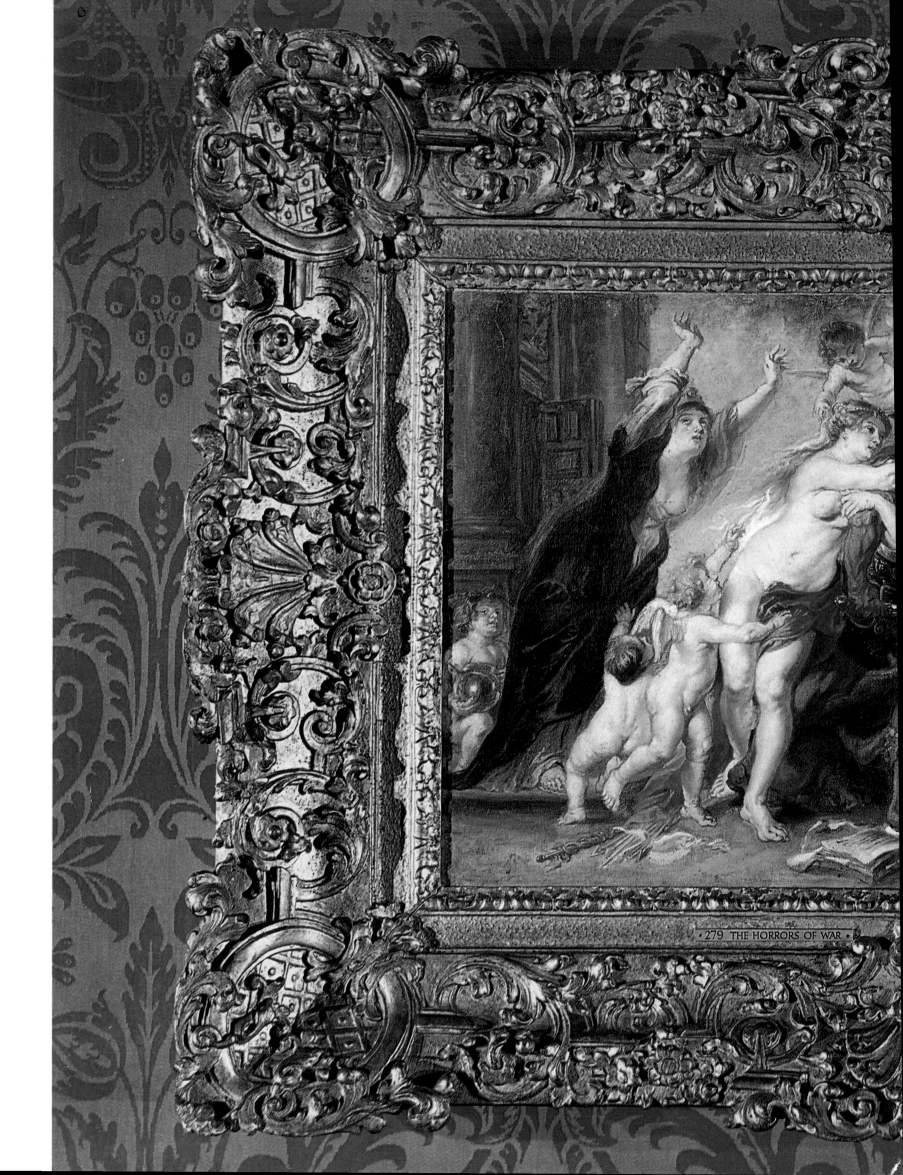

· 279 THE HORRORS OF WAR ·

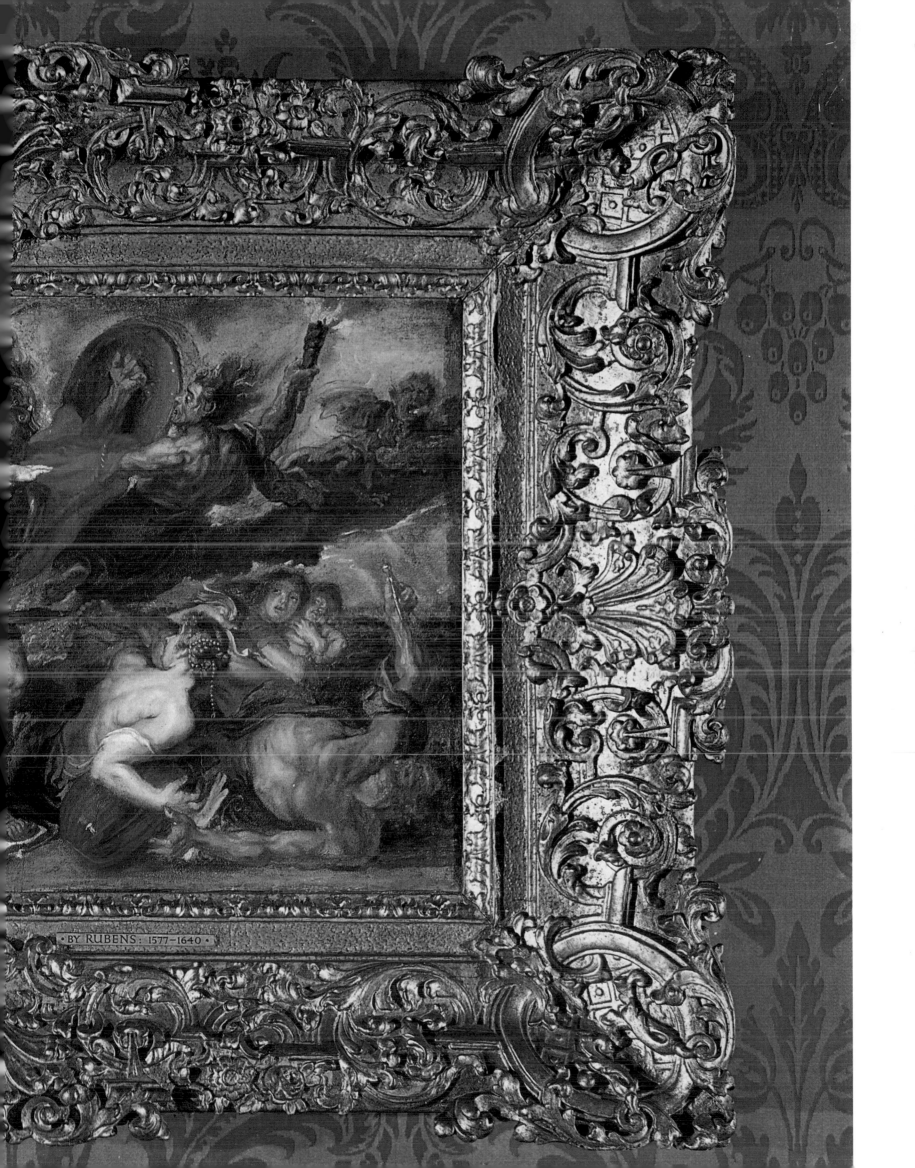

· BY RUBENS · 1577–1640 ·

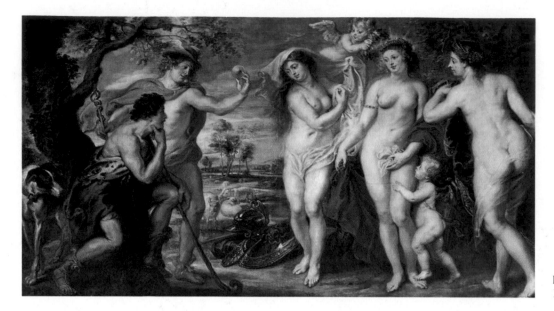

Rubens: *The Judgement of Paris,*
199 × 379cm, 1638–9

Peace and War as a present to Charles I of England. Rubens' diplomatic mission to England in 1629–30 was the great success of his public career and led Philip IV of Spain to overcome his reluctance to employ a painter for such important matters. As a diplomat, however, Rubens was ultimately unsuccessful, deciding in later life to abandon public life altogether and to retire to his country house at Steen. The peace that Rubens constantly advocated was essentially the peace that only Spain could bring to Europe, and this led to the very naive conviction that Philip IV should interfere in French politics and bring back forcibly the deposed Marie de Medici; only then, he argued, would there be a peace 'throughout all Christendom'. The language of mythology itself loses its validity in the context of political reality. No matter what the conviction behind the artist's painted allegories, such occurrences as Marie de Medici's rather humiliating loss of power, the execution of Charles I, or the persistence of war, hinted at a less glamorous truth.

The attractively accessible nature of Rubens' character and art contrasts markedly with the austere hermeticism of the other great seventeenth-century Stoic, Poussin. Poussin was one of the first mythological painters since fifteenth-century Florence not to have worked for any length of time at a court; in fact on the one occasion, in 1642, when he gave in to considerable pressure and went to Paris to work for Louis XIII, he could not wait to get back to his preferred domicile in Rome. The friends he made on his short trip to Paris, who were to remain his patrons for the rest of his life, were not courtiers, but instead from the intellectual, financially unostentatious, middle classes, merchants, minor bankers and civil servants. A similar lack of both genuine political power and excessive wealth characterized his patrons in Rome, notably Cassiano del Pozzo. This high-powered intellectual of wide-ranging interests was obsessed by classical archaeology, but unable to buy any original antique, commissioned a team of artists, including Poussin, to record all Roman remains that were dug up. The stimulus to Poussin's mythological paintings was provided by this more serious and scholarly-based intellectual culture; in later years these same enlightened patrons of the middle classes were to turn against the world of mythology.

Very different again to both the aristocratic clientele of Rubens and the scholarly circle of Poussin was the exclusively bourgeois art-buying public of seventeenth-century Holland. This public's mistrust of mythological painting can partly be explained by both the more puritanical, civic-minded environment and the association of this type of painting with the values which they so despised in neighbouring Flanders, a hierarchical and fervently Catholic country. The root of the problem goes, however, much deeper than this; looking back into the whole history of North European attitudes towards mythology one realizes how exceptional was the position of Rubens and his school. Initially, at the beginning of the sixteenth century, reports of the increasing fashion in Italy for paintings with naked figures acting out pagan scenes must have given the southern country the semblance of a refreshingly hedonistic paradise. Northern artists, for example Jan Metsys, who actually went to Italy, would have strengthened such reports, in works like *Flora,* in which the sensuality of the subject is heightened by the exotic background of the Bay of Naples. For northern artists who never left their own country, the task of illustrating classical mythology – as Deutsch did in his remarkable *Judgement of Paris* – stimulated their inherent love of fantasy. By and large, however, nudes seemed remarkably out of place in a northern environment. The peculiar eroticism of Cranach's nudes, for instance, is due to their extreme self-awareness, the fact that they are quite obviously contemporary types who are daringly revealing themselves. In other mythologies by Cranach, such as the *Hercules and Omphale* commissioned by Cardinal Albrecht of Brandenburg, the artist created instead a painting that is more like a genre scene. The same could also be said of Bruegel's *Fall of Icarus,* where the tale from Ovid is reduced to a barely discernible event in the background, while a much greater part of the painting is taken up by a view of a farmer ploughing the fields. This preference for the every-day scene, combined with an inability to fully integrate classical legends – which, after all, took place in a very different climate – into the less sensually inviting atmosphere of a northern country, characterizes Dutch art of the seventeenth century. Apart from the artists working at the court of The Hague, Rembrandt was one of the exceptional Dutch artists to attempt mythology, and even so, very rarely. His love of

OPPOSITE **Deutsch:** *The Judgement of Paris,* 223 × 160cm

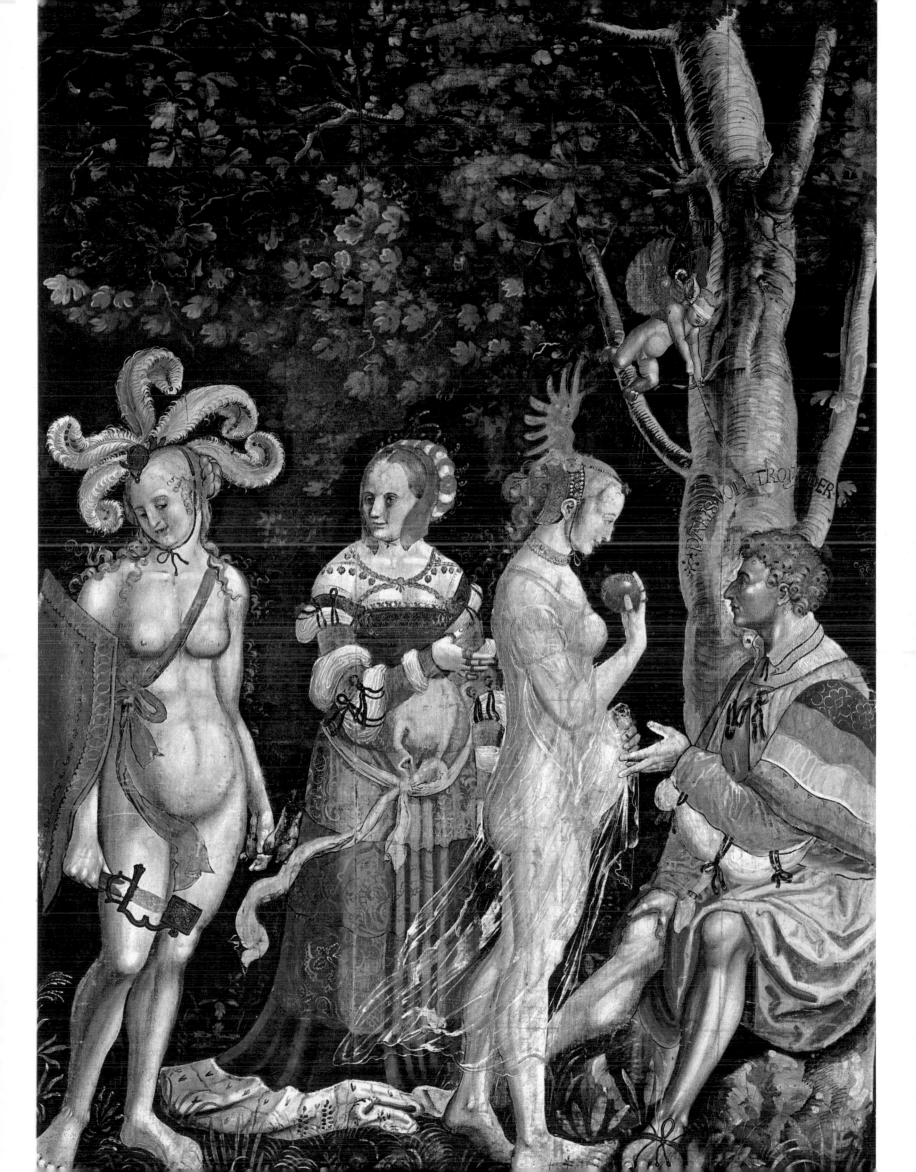

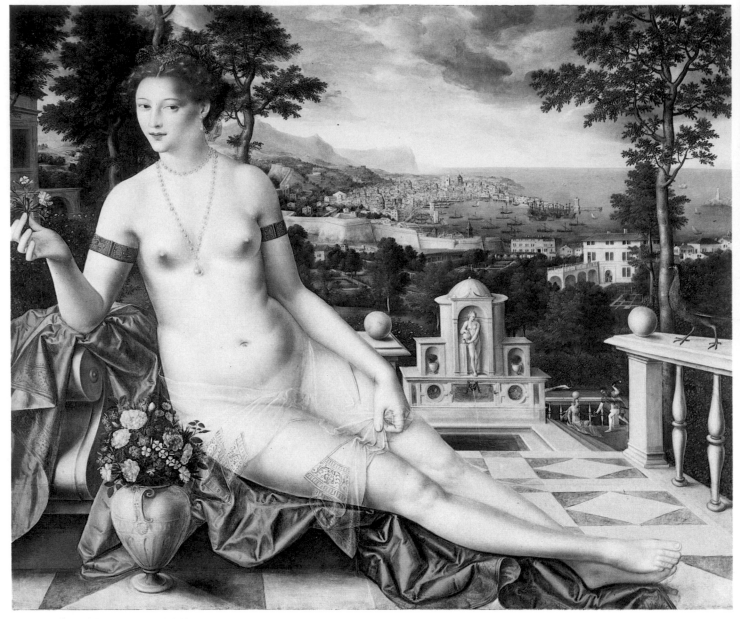

Metsys: *Flora*, 130 × 156cm, 1561

the exotic and dramatic made such subjects as *The Rape of Proserpina* an attractive proposition, but in later life the realization that mythology unsupported by a deep respect for classical literature can be a very frivolous affair, must have seemed out of character with his artistic intentions. Painted at a time when he could still show a considerable sense of humour, *Ganymede* is generally given as an example of the artist's anti-classical stand; the beautiful young boy taken up to the heavens to satisfy Jupiter's bisexual tastes is replaced by an ugly baby grimacing and urinating in anger and fear. The spirit of the work, although totally different from that of the late Rembrandt, is not, however, so dissimilar from that of so many of the great mythologies of the Renaissance and Baroque, including Correggio's version for Federigo Gonzaga. A complete break with tradition is, in contrast, represented by Vermeer's *The Studio*, which detaches itself from all the classical paraphernalia that surrounds allegory, by showing the artist at work painting one. Whatever the exact meaning of this canvas, one senses a new, more rational spirit questioning both the absurdities

and the mysteries on which so much of the art of the past was based.

A similarly new quality is felt in the mythologies of one artist whose work seems to stand completely outside the context of his time, and to defy any generalization about the development of mythological painting or the type of patronage and atmosphere favourable to it. This artist was Velazquez, Court Painter to Philip IV at Madrid. The number of renowned mythologies that were brought to Spain in the sixteenth century has already been noted, and this trend was continued during the reign of Philip IV, during which time the already large collection of pictures by Titian was augmented by the paintings from the Ferrara *studiolo*; Rubens, it must be remembered, also contributed an enormous series of Ovidian scenes to the Torre de la Parada. One would have thought that this wealth of visual material would have inspired a healthy mythological tradition among Spanish painters; but this is far from being the case, the usual and unsatisfactory reason given being the intense Catholicism of the country. Velazquez is the one major excep-

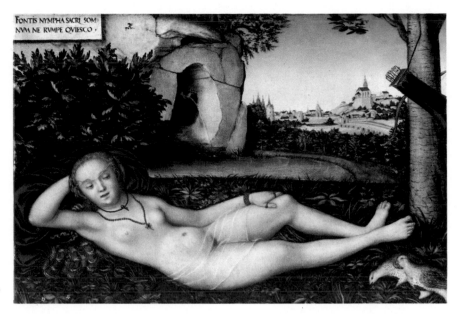

Cranach the Elder: *Nymph of the Source.*
48·5 × 73·9cm, after 1537

tion, and yet in his treatment of mythologies he appears to have remained entirely indifferent to the many examples which he could have seen around him. A strangely unexplored clue to this enigma lies, perhaps, in Spanish literature, which produced a wide and exciting range of mythological-inspired works throughout the sixteenth and seventeenth centuries. As well, with the publication in 1554 of the anonymous *Lazarillo de Tormes*, Spain witnessed a new literary genre, the picaresque novel, which offered, in a series of brutally realistic accounts of innocent youths turning through necessity into hardened criminals, a potent alternative to so many quaint pastoral idylls. Out of this new realism developed a characteristically Spanish taste for the most malicious and grotesque satire, a tradition exemplified in the

Pieter Bruegel the Elder: *The Fall of Icarus.* 73·5 × 112cm, 1567–78

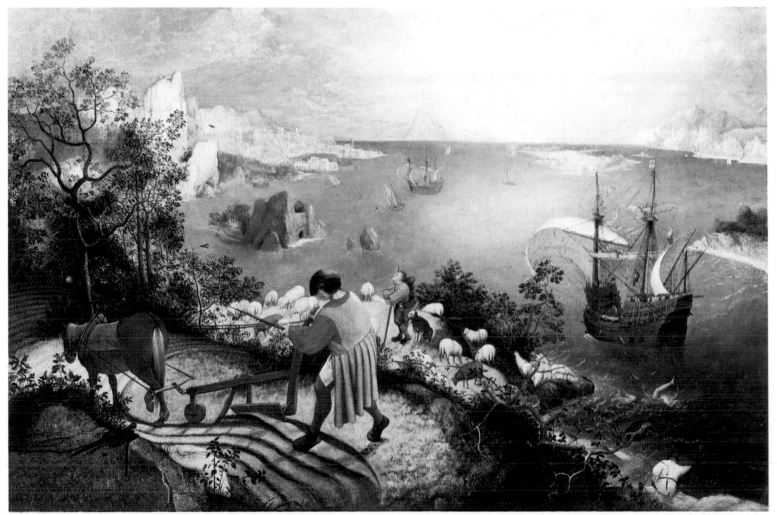

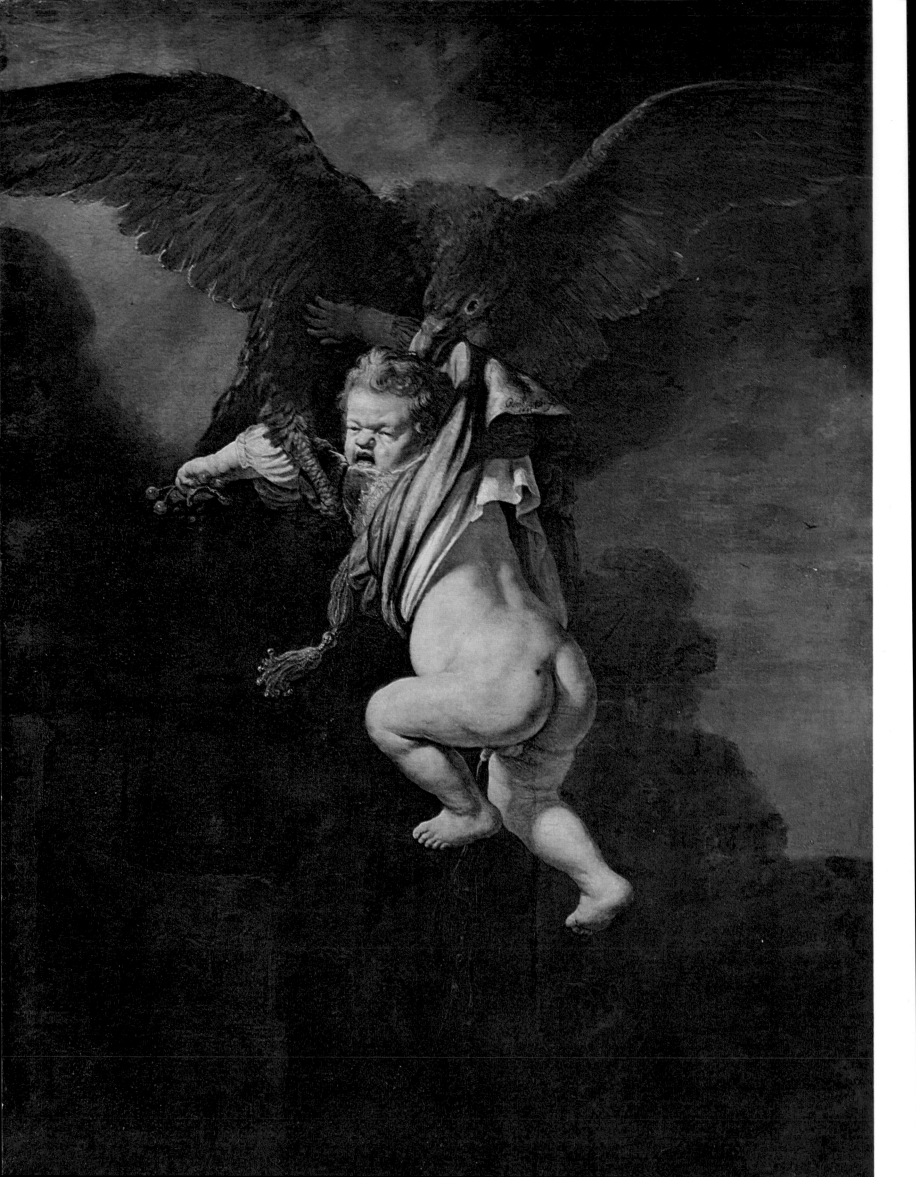

writings of Quevedo, whose daunting, bespectacled face was, in fact, painted by Velazquez. Something of the satirical vein of Quevedo is undoubtedly echoed in Velazquez's relatively early *Topers*, but the old assumption drawn from this that the artist, like Rembrandt in his *Ganymede*, was taking an anti-classical stand, has rightly been questioned. Recently, however, critical opinion has gone too far the other way, going to inordinate lengths to try and find respectable classical sources for all of Velazquez's work. Just in what spirit one should approach Velazquez's mythologies, still remains in doubt, but perhaps the closest literary parallel is to be found in Cervantes' *Don Quixote*, in which the pastoral and the

Rembrandt: *The Rape of Proserpina*, 83 × 78cm, 1628–9

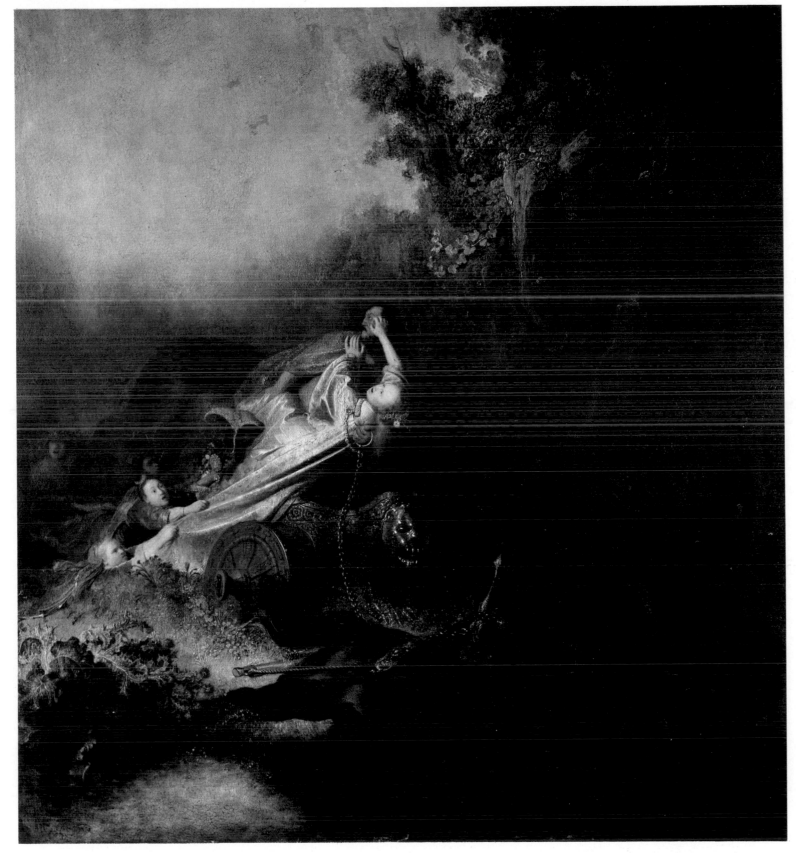

Vermeer: *The Studio,* 130 × 110cm, 1666

Below **Velazquez:** *The Spinners*, 220 × 289cm, c.1657

Velazquez's culminating and most elliptical mythology survives in rather a damaged state, and has also the unfortunate addition of a large strip of canvas on top: without this offending strip, the abrupt transition between foreground and background becomes more dramatic still. The choice of subject from the *Metamorphoses* was as unusual as its treatment, yet it is easy to see why Velazquez was apparently so attracted to it. Firstly, to an artist who saw mythology in a very human way, his sympathies must immediately have been with the mortal girl, Arachne, who, when competing with the disguised Minerva in a tapestry-weaving contest, cheekily decided to portray the gods in their guise of heartless seducers, while her rival showed them up in more glamorous light. Secondly, Ovid's text evoked a scintillating range of colours which was bound to appeal to an artist as colouristically daring as Velazquez. He suitably included in the *Spinners* a homage to the greatest colourist of an earlier generation; the tapestry in the background of the painting, showing the rape of Europa, the first subject to be woven by Arachne, is after one of Titian's famous *poesie* for Philip II.

Velazquez: *The Topers*, 165 × 225cm. 1629

picaresque are perfectly aligned. The combination of mythological figures in a realistic setting, especially in the artist's later works, seems to go well beyond the range of mere parody. The culminating mythological work of the artist is the painting that until very recent times was known solely under the title of *The Spinners*. It was considered to be a real-

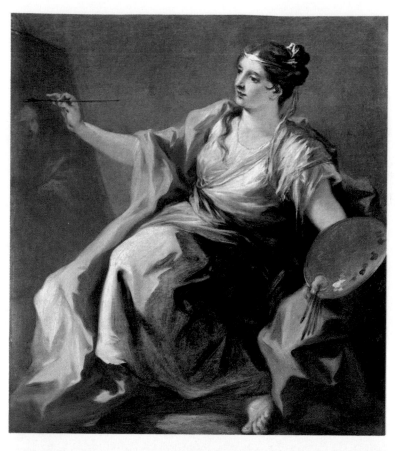

istic depiction of the Royal Tapestry factory at Aranjuez, but it is now recognized as an illustration of Ovid's fable of Arachne. There is evidence that Velazquez had the degree of learning to be expected from someone who was a courtier, but what is important is the deeply imaginative use to which he put this. In the foreground, the spinning competition between Minerva, disguised as an old woman, and the mortal Arachne is depicted with all the sense of effortless speed described by Ovid. Rather than showing the gruesome outcome of this story, with Arachne transformed into a spider, Velazquez shows Minerva's triumph, and clearly some allegory of the arts is intended. The painting's specific meaning is debatable, but anyone approaching the work without the slightest consciousness of what it might represent, must be aware, as so often in Velazquez, of some transformation of reality, in which the eye is led from the realistic and relatively subdued foreground to a distant and very colourful world of fantasy. Such speculation constitutes a very contemporary approach towards art, but the fact that it can be made indicates that with Velazquez's mythologies, more than with those of any other artist, one senses an artist who, instead of following a tradition, is actually respon-

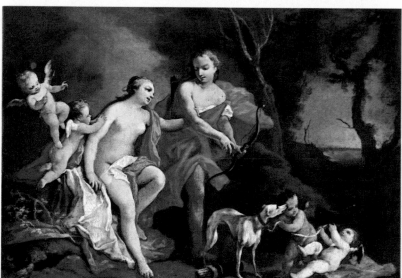

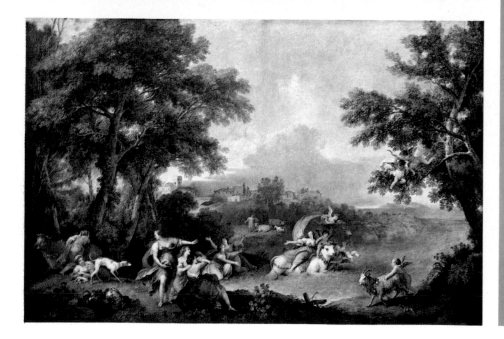

Above **Pellegrini**: *Painting*, 142 × 132cm, 1725–30
Left **Amigoni**: *Venus and Adonis*, 54 × 74cm, c.1745
Below **Zuccarelli**: *The Rape of Europa*, 142 × 208cm, 1740–50

One of the livelier centres of painting in eighteenth-century Italy was Venice, but with the exception of Tiepolo, none of its artists managed to breathe new life into mythology. An artist like Pellegrini treated religious, mythological and allegorical subjects, all with the same technical facility and lack of interpretative concern; his allegory of 'Painting' is no more than one of a series of pretty women, painted very quickly in purposely appealing colours. Landscape, in the hands of a seventeenth-century artist like Saraceni, Poussin and Claude, at times dominated the mythological subject, but at least its mood had echoed the story, and its derivation from the Roman *Campagna* had given a firm basis in reality to the classical text; the mythological backgrounds in the paintings of Zuccarelli, who was regarded as one of the greatest landscape artists of his time, were as thoughtlessly painted as the purely decorative subjects in front of them. Finally Amigoni's version of Ovid's story of *Venus and Adonis*, showing the moment when Venus tries to dissuade her lover from hunting, should be compared with Titian's painting of the subject for Philip II; the drama of Titian is replaced in Amigoni by a spirit of half-heartedness. Amigoni's paintings of this sort were immensely popular, and they frequently appear in the middle-class interiors of the genre painter, Longhi, their importance as figurative art no greater than the frames which surround them, or the walls to which they make a graceful and unobtrusive addition.

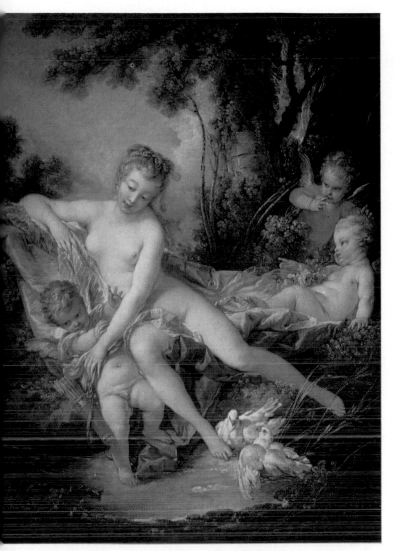

Boucher: *Venus Consoling Love*, 107 × 85cm

Below **Boucher**: *The Triumph of Venus*, 130 × 62cm, and detail pages 74–5, 1740

Rococo painting is not held in high esteem today, but it is perhaps unfair to adopt a reverential attitude towards an artist like Correggio, while disparaging Boucher. The latter's *Triumph of Venus* has as its guiding principle a belief in pleasure, a principle shared by many of the great artists of the Renaissance and Baroque. Unlike the mythologies of his Venetian contemporaries, which are generally no more than decorative, the *Triumph of Venus* at least holds the attention through its eroticism, and, in fact, even an artist like Correggio would have envied the porno-graphic freedom which Boucher was allowed; in this case on of Venus's maidens, excited by the fluttering dove between her legs, lies back apparently to masturbate, and, elsewhere, the cupids themselves join in the general fun, relishing the feeling of a caressing leg on a stomach, or playfully investigating a bottom. This might not be profound art, but perhaps in the case of paintings of earlier centuries, one is misled by apparent profundity, by the fact that art historians can, if they really want to, read complex philosophical truths into them; with the paintings of a Boucher, the art historian, in his role of would-be humanist, is made redundant. In a book, however, concerned with mythological painting as a definite tradition, one must conclude that the function of classical mythology as a fresh, humorous and erotic alternative to religious art lost its exclusiveness in the eighteenth century; by Boucher's time, for instance, the world of China had a similar, if not greater appeal, as an exotic paradise, and classical disguise was no longer necessary to works of pure pornography. As a final rejoinder, one should also note that the world of a Boucher could not accommo-date any of the violence, which had given so much conviction to the art of a Titian or a Rubens. Myth-ology, no longer satisfying the need for something more sensational and pungent, was obviously limited in its scope, and the stirring art of a David was to be the necessary corrective.

ding to the myths in the searching spirit so much admired today.

The classical myths have continued to inspire artists right up to the present, but there is a difference between isolated examples by artists like Delacroix, Moreau, Kokoschka or Picasso, and the more universal mentality that created a definite tradition. The changes in this mentality, changes that led to the considerably decreased importance of mytho-logical painting, can be clearly traced in the eighteenth century. First, in art theory, the dogma of *ut pictura poesis*, the central basis of the humanistic theory of painting, was being challenged, most methodically by Lessing in his *Laokoon* (1766), which relegated painting and poetry to their respective places. Much earlier, the less earnest French critic, De Piles, had suggested that the painter should not follow strict theoretical rules, but should be more guided by his own imagination. De Piles' more empirical approach was shared by later writers on art, like Reynolds and Algarotti, who, although stressing the importance of classically inspired subject matter, showed a considerable flexibility which could accommodate both the importance of painterly qualities and, again, that of an artist's sense of fantasy. The intellectual pretensions of mythological paintings of the sixteenth and seventeenth centuries largely disappeared in the eighteenth,

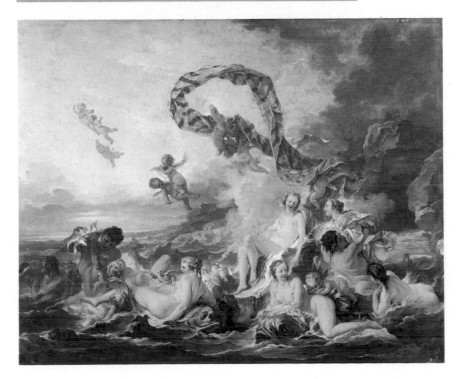

Boucher: *The Triumph of Venus* (detail)

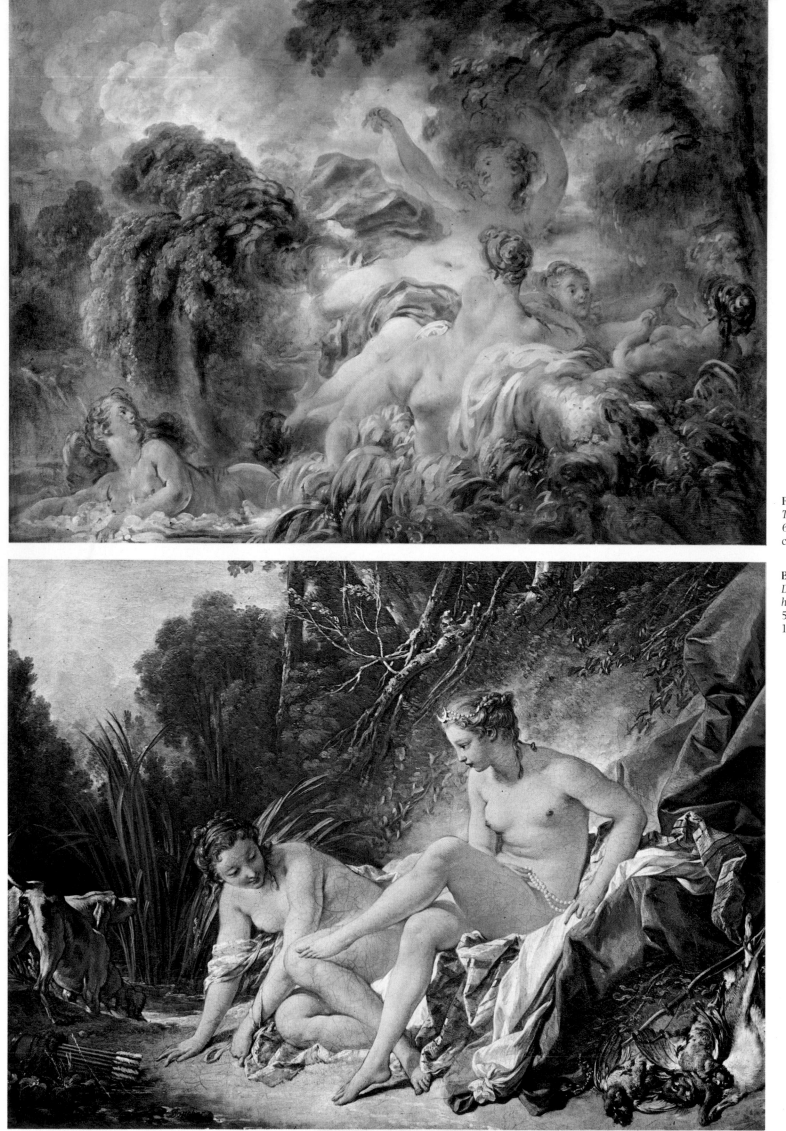

Fragonard:
The Bathers,
65 × 81cm,
c. 1765–70

Boucher:
*Diana after
her Bath*,
56 × 73cm,
1742

and certainly there were no more Poussins. The more frivolous side to mythology took over completely, but without any of the compensating pungency. Indeed much art became purely and openly decorative. New categories of painting were formed: Diana and her maidens, who by Boucher's time were quite shamelessly preening *coquettes*, as in *Diana after her Bath*, became, in the hands of a Fragonard, simply *Bathers*. The *Fêtes Galantes* of Watteau took over from the pastoral landscapes of a Claude, but in their total exploitation of mood, unrelated to any desire to recreate the classical world, they broke away from the tradition. The *Departure from Cythera* has no precise classical subject matter, but is rather an impressionistic evocation of the sadness occasioned by a group of languorous and fancifully dressed people leaving behind the Island of Love. The painting's spirit of finality epitomizes that of so much art of the eighteenth century.

Patronage also was changing. The series of circumstances leading up to the French Revolution meant an increasing threat to court culture, which had often been the life-blood of mythological painting. The Venetian painter, Tiepolo, the last great painter in the Renaissance tradition, was also the last to glorify in paint an exclusively reactionary and aristocratic clientele, culminating in the Spanish monarchy. Unlike Rubens, Tiepolo displayed little evidence of great learning and certainly no strong philosophical or political convictions; his triumphant ceilings extolling the virtues of incongruous historical personalities succeed through the conviction of technique alone. In France, changes were more firmly under way, and in the wake of the Revolution, the frivolity of mythology had no place. Classical history painting has so far not been mentioned, but in times of renewed emphasis on civic virtues it assumes a dominant importance. Already in seventeenth-century Holland, artists, including Rembrandt, when commissioned to decorate the new Town Hall, had been asked to illustrate ancient history and not myth; this more rational spirit was shared by Neoclassical artists like David, but even his own brand of history painting was shortly to seem absurd, something emphasized by the novelist, Stendhal, when describing, in 1824, David's *Intervention of the Sabine Women*: 'We are on the eve of a revolution in the fine arts. Large pictures of thirty naked figures copied from classical statues . . . are doubtless very estimable works. But they are beginning to bore us . . .'

David: *The Intervention of the Sabine Women*, 386 × 520cm, 1797

Claude: *Ascanius Shooting the Stag of Sylvia,* 120 × 150cm, 1682

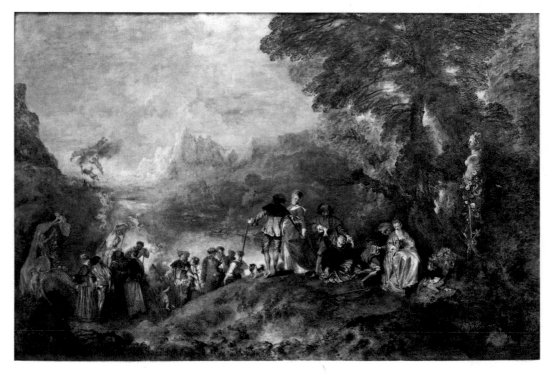

Watteau: *The Departure from Cythera,* 128 × 193cm, 1717

In the case of Goya's *Saturn Devouring his Children*, rather than being conscious of the swan-song of mythological painting, one is aware of a very new spirit. The work must have been directly inspired by one of the Ovidian scenes by Rubens destined for the Royal Hunting Lodge near Madrid. A comparison between the two works can lead to some very crude conclusions, but what is important is that Goya's holds a much greater interest for the public of today. A private, uncommissioned painting, Goya's *Saturn* has a personal quality, which appears to meet today's major criterion for a great work of art, anguished sensibility. Although not necessarily reflecting a tormented mind on the part of the artist, it nonetheless remains a powerful image of a country, Spain, torn apart by the horrors of war. No such claims can be made for the mythological paintings of the past, which, even at their most violent and technically personal, like Titian's

Rubens: *Saturn*, 186 × 87cm, 1636–7

Goya: *Saturn Devouring his Children*, 146 × 83cm, 1819–23

Flaying of Marsyas were essentially intended for a public who enjoyed seeing the depictions of their favourite classical stories. The exaggerated seriousness with which art is now taken, the belief that it mysteriously enhances the quality of life, is not the right spirit with which to approach mythological paintings. Even in the past, attempts of art theorists to give these paintings a philosophical status had largely failed by being set against the more straightforward concerns of painter and patron alike. When mythology was used as propaganda, or to expound complex philosophical principles, its currency was limited. What survives now is only the occasional intimation of a universal truth, a function of mythology that is itself no more than an enjoyable way of finding visual images for indefinable mysteries. More importantly, stripped of all ephemeral associations, mythological paintings retain their humour, eroticism and love of the sensational, qualities that can too easily be ignored if one looks for a much deeper experience. In the past these same qualities were the cause of religious doubts, but it is now art, and not religion, that has to be reconciled with pleasure.

List of Illustrations

Bibliography

BLUNT, SIR ANTHONY: *Nicolas Poussin*, 1967
PANOFSKY, ERWIN: *Meaning in the Visual Arts*, 1970
WETHEY, HAROLD: *The Paintings of Titian, Vol. III. The Mythological and Historical Paintings*, 1975
WIND, EDGAR: *Pagan Mysteries of the Renaissance*, 1958
YATES, FRANCES: *Astraea: The Imperial Theme in the 16th Century*, 1975